THE TECHNIQUE OF PORCUPINE-QUILL DECORATION AMONG THE NORTH AMERICAN INDIANS

BY

WILLIAM C. ORCHARD

EAGLES VIEW PUBLISHING
1984

ISBN 0-943604-00-1

Foreward

This book became a recognized classic soon after it was first printed in 1916. Both the first edition and the reprint in 1971 were produced by the Museum of the American Indian, Heye Foundation, of New York, and we owe them a great deal for their cooperation and support. We wish to thank Dr. Roland Force and his fine staff for their assistance.

Porcupine quill decoration is a craft that is unique to the Indians of North America; a craft that can be found no where else in the world. Prior to about 1840 it was the principal means of decoration among most of this continents Nations and as such one would suppose that there would be innumerable studies, books and articles about the subject. One of the reasons for this edition of Orchard's work is that such is not the case. Some sixty-six years after the first publication, this work remains the best single source on porcupine quill work.

As was done in the 1971 reprint of the first edition, we have made no attempt to revise the original text. The map was created for the reprint by Mr. Douglas Waugh and has not been changed. The plates, however, require some further explaination.

As the author refers repeatedly to the black and white Plates we felt it very important that they be of the best quality possible. It is only because of the cooperation of the Heye Foundation that we hope to have achieved this goal. Through the effort of their photographic department we were able to locate most of the original negatives of these Plates and these photographs are used courtesy of The Museum of the American Indian, Heye Foundation. The negatives for Plates IX (Page 33), XI (Page 39) and XXII (Page 70), however, had been destroyed and we were forced to copy them from the book. We owe the quality of this process to Commercial Press, Printing Co. The negative for Plate XXVII (Page 81) was also destroyed and has been replaced by a photo of Ojibwa quilled boxes from the collection of the editor.

Of the Color Plates, only Plate XVI was in existence. We have replaced the missing photos with those of relatively contemporary quilled articles from the editor's collection. This was done both because the color adds to the book and to show that the craft continues. All of these items were crafted by members of the Rosebud Sioux Nation. The Photo of William C. Orchard was also supplied by the Heye Foundation staff.

The Eagles View Edition of this book is dedicated to the memory of William C. Orchard and serves as a testimony to the worth of his endevours; this exploration of quill work and his later **Beads and Beadwork of the American Indian** are the definitive studies of their respective subjects. Through these books and his many years at the Heye Foundation he has made an indelible contribution to the continuation of a unique and lasting culture.

Monte Smith
Editor

April 1982

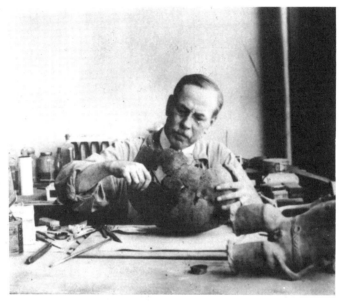

William C. Orchard, examining a Museum specimen.
September-1917

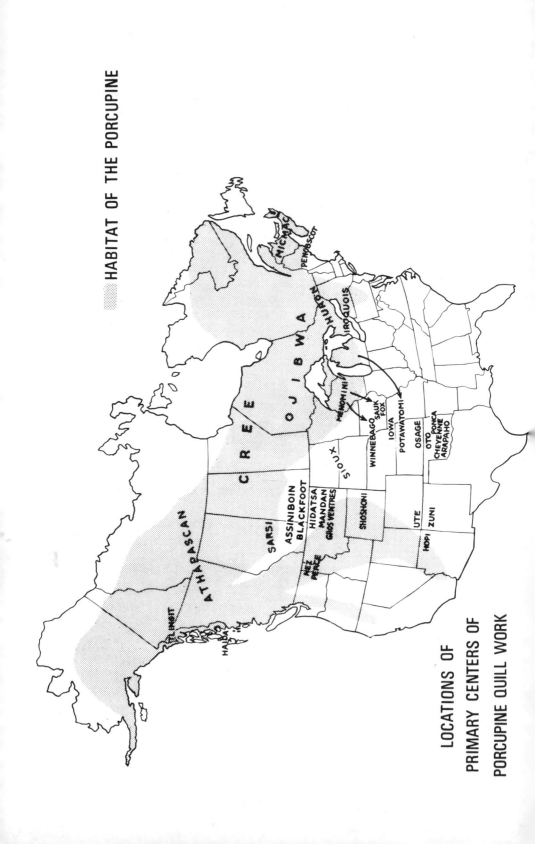

HABITAT OF THE PORCUPINE

LOCATIONS OF
PRIMARY CENTERS OF
PORCUPINE QUILL WORK

THE TECHNIQUE OF PORCUPINE–QUILL DECORATION AMONG THE NORTH AMERICAN INDIANS

BY

WILLIAM C. ORCHARD

INTRODUCTION

WHEN we consider the hardships connected with the primitive life of the North American Indians, particularly that of the wandering tribes of the great plains, it at first seems hardly possible that the women should have had either the inclination or the time to devote to elaborate embroidery; nevertheless there is abundant evidence of the fact that many hours have been spent on a single object in the desire to give expression to esthetic concepts. Examples of bead and porcupine-quill work attesting to the artistic ability of the Indians form a part of all well-known collections.

Porcupine-quill work is especially interesting by reason of the remarkably fine stitches that have been employed and the ingenuity displayed in the manipulation of the quills to produce effective designs. Indeed many specimens exhibit such skill as to be worthy of inclusion among the fine arts, where sewing and the selection of colors are important desiderata.

The purpose of this paper is to describe the technique and to attempt to bring about an appreciation of the complexity of the art of porcupine-quill work and the tireless patience that must have been exercised in producing such exquisite effects.

Specimens of the finest work were collected many years ago, and in most cases are without information as to their origin. However, comparison of technique and design with modern work, although vastly inferior, has furnished clues, so that the probable source of production may be given for those earlier and finer specimens.

The drawings and explanations of the folding of the quills and stitches are chiefly the result of technical analyses. Some of the simple foldings have been demonstrated by modern workers. Only the constructive branch of the art will be considered.

Specimens have been collected from Alaska to Maine, including the woodland tribes and those of the great plains, and, as might be expected, they show conformity in design peculiar to the various tribes. The desire for designs of symbolic import stimulated the inventive genius of the artists, so that a remarkable number of complex foldings of the porcupine-quills and stitches have been devised.

Thanks are due to the officials of the United States National Museum at Washington, the American Museum of Natural History, New York City, and the Field Museum of Chicago, who kindly afforded facilities for the examination of their collections. The extensive collections of the Museum of the American Indian (Heye Foundation) in New York, generously placed at my disposal in connection with this study, have been of valuable assistance in furnishing all but two of the techniques described.

Early Use of Porcupine-quills

In the records of early explorers of North America occasional though somewhat indefinite references are made to the decorative art of the aborigines. Among the materials used as a means of decoration, porcupine-quills are frequently mentioned. Harmon, in his *Journal of Voyages and Travels in the Interior of North America*, writes: "The women manifest much ingenuity and taste in the work which they execute with porcupine quills. The colour of these quills is various, beautiful and durable, and the art of dyeing them is practised only by the females." In *Manners and Customs of Several Indian Tribes*, John D. Hunter mentions men's headdresses as being "neatly ornamented with feathers, porcupine quills, and horsehair stained of various colours . . . their waist-cloths, leggings, and moccasins, omitting the feathers, are decorated in the same manner as their caps." Other writers might be quoted who in a similar manner mention this particular form of decoration,

hence it is reasonable to suppose that porcupine-quill work is an art whose practice antedates the advent of people from the Old World and their influences on the arts of the American aborigines.

DISTRIBUTION

The porcupine has a widely distributed habitat in the northern part of the North American continent. Reference to the map (pg. 2) will show the boundary-line extending from northern Labrador and across the southern shores of Hudson bay, northwesterly to beyond the Arctic circle in Alaska. The southern line includes New Brunswick, Nova Scotia, and Maine, thence follows a southerly trend into Pennsylvania, whence it turns toward the north and includes the Great Lakes region, pursues a northwesterly course to Alberta, there making a sudden turn toward the southeast, following the Rocky mountains and crossing the northwestern corner of Colorado and the southeastern part of Utah, through Arizona to the California line, there turning to the northeast, clearing Nevada and passing through Idaho, to British Columbia and Alaska. A narrow strip of territory extends toward the south. including the Cascade range, parts of the states of Washington and Oregon, and northern California.

A point of interest in connection with the habitat of the porcupine is the fact that this animal is not found in the country inhabited by those tribes which are today and have been in the past the producers of a great quantity of porcupine-quill embroidery. This may indicate that our Indian friends, like white people, desired the things most difficult to obtain for their personal adornment. On the other hand, Labrador and Alaska are included within the boundary, but the natives of those regions, excepting the Tlingit, have not contributed to the collections so far as can be learned.

BIRD-QUILL WORK

The Alaskan Eskimo, however, have made use of bird-quills, which, after being stripped of the rami, are split and the pieces woven into designs for belts. Figure 1 is an enlarged drawing of such a piece of work. It will be seen that the split quills are woven

over and under a series of warp strands, and edged with a strand along the face of the work, which is caught by another strand along the back, passing through between the quills at somewhat regular intervals and looping over the strand in front. The drawing indicates an alternation of colors, black and white. To effect this there is a double layer of quills, laid in series of threes or fours.

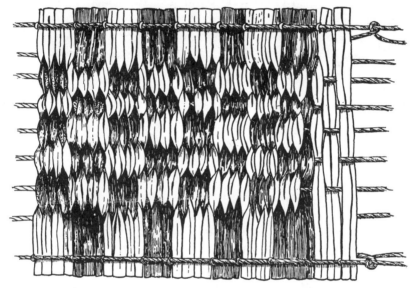

Fig. 1.—Bird-quill work of Alaskan Eskimo. (Enlarged.)

In the upper left-hand corner of the figure are four white quills, while black quills come to the front beneath them; still farther below the white quills are brought forward, and so on to the end. Although the lines are irregular, the effect is suggestive of the checker-board pattern. The finished weaving is sewed to a strip of leather, the edges of which are turned up and over the ends of the quills.

Bird-quills have been used to a small extent, either independent of, or in connection with porcupine-quills, by the North American Indians. Before discussing the technique of the art of porcupine-quill embroidery it may be well to introduce at this time a description of some of the pieces of bird-quill work that have been examined in connection with the preparation of this paper.

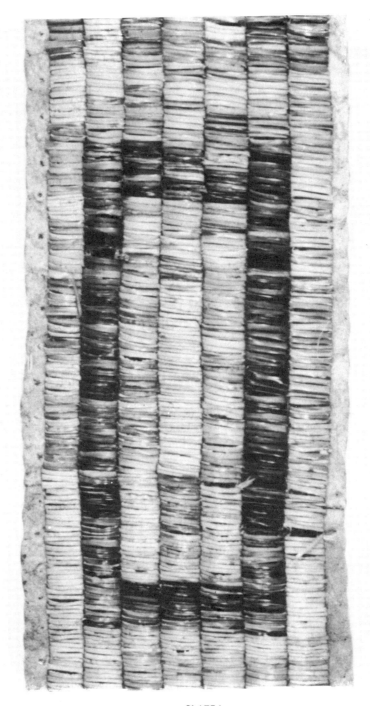

PLATE I

BIRD QUILL DECORATION ON BUFFALO HIDE: DETAIL

1/3804 HIDATSA. FT. BERTHOLD, NORTH DAKOTA 4x19 IN.

A split bird-quill is frequently found where an edging has been made, either on the extreme edge of a piece of leather that has been decorated, or surrounding a pattern that has not been worked out to the edge. In such cases the bird-quill has been used as a filler, that is, the porcupine-quills are wrapped around the bird-quill and then sewed to the leather, as shown in figure 48. In some instances, however, a strip of leather or a cord has been used for the same purpose, perhaps because the bird-quill was too stiff to produce the soft, graceful curves obtainable with other materials.

The best examples of work examined in which bird-quills have been used exclusively are to be found in the Museum of the American Indian. These consist of five pieces, 3¾ inches wide, the total length being 9 feet 4 inches (pl. 1), and no doubt were intended to be used in a single long strip, in all probability as a decoration for a tipi cover. The method employed in fastening the quills is shown in figure 8. There are two objectionable features in the use of bird-quills, namely (1) the uneven, ragged appearance of the edges, due to splitting, which to a great extent mars the neatness that is so characteristic of the work in which quills of the porcupine are used; (2) they do not make a clean, sharp fold where they are turned under the stitches, hence the edges of the patterns are uneven and the whole presents the appearance of an inexpert piece of work, and to the stiffness may be due the absence of any form of decoration other than geometrical.

One or two instances have been noticed in which the two kinds of quills are used alternately in working bands of embroidery, and there are some examples in which grass has been employed in the same manner.

MATERIALS FOR PORCUPINE-QUILL WORK

During the summer of 1911 the writer made a hurried trip through the Sioux reservations in North Dakota and South Dakota, and a visit to the Ojibwa living near the shores of Georgian bay, Ontario, for the purpose of gathering all available information regarding materials and the various methods of preparing them, as well as of gaining an insight into the processes employed in the art of porcupine-quill work.

The designs were worked out mostly on soft tanned leather or on birchbark. An exception, however, is a woven technique which will be described. The tanning of leather or deerskin has been described by others, hence the necessity of here describing that process is obviated. The preparation of birchbark consists merely of shaping, perhaps splitting, and laying out the pattern to be worked. Hunting the porcupine fell to the lot of the men, and so far as could be learned, they sometimes plucked the quills from the living animal. One method of capture was to trace a porcupine up a tree by means of the freshly gnawed bark; the bow and arrow, or in later days a gun, was then used to dislodge it. Another method was to find a burrow that bore evidence of being inhabited, when the porcupine was dug out. A soft-tanned skin or a blanket was used to prevent escape. Various kinds of traps also were used.

Considerable attention was given to the sorting of the quills as they were plucked, which operation was performed without removing the skin. Four sizes of quills were found on the animal, and were graded accordingly. The largest and coarsest came from the tail, which were used in broad masses of embroidery, where a large surface was to be entirely covered, or for wrappings on club-handles, pipe-stems, and fringes. The next size came from the back, and still smaller quills from the neck. The finest were taken from the belly, and were used for the most delicate lines so noticeable in the exquisite work to be found in early specimens. The various sizes were kept in separate receptacles made from a bladder of an elk or a buffalo. After the quills were all plucked, the hair was singed from the body and the animal was cooked entire, being a highly esteemed delicacy.

Dye Materials and Dyeing

The selection of materials used for coloring was governed to a great extent by the locality in which the work was to be done, although sometimes long journeys were made to procure choice materials to serve as ingredients for making dyes.

Since the introduction of aniline dyes very little use has been made of the native products, consequently present information

respecting the old methods is sometimes vague, and early writers refer but little to the subject. From Maximilian[1] we learn that among the Blackfeet, "to produce the beautiful yellow colour, they employ a lemon-coloured moss from the Rocky Mountains, which grows in the fir trees. . . . A certain root furnishes a beautiful red dye, and they extract many other bright colours from the goods procured from the Whites. With them they dye the porcupine quills and the quills of the feathers, with which they embroider very neatly." The Cree women, according to the same author,[2] "understand how to dye a beautiful red with the roots of *Galium tinctorum* and *boreale*, and black with the bark of the alder."

Harmon,[3] writing of the Indians living east of the Canadian Rockies, furnishes a little more detailed information: "To colour black, they make use of a chocolate coloured stone, which they burn, and pound fine, and put into a vessel, with the bark of the hazel-nut tree. The vessel is then filled with water, and into it the quills are put, and the vessel is placed over a small fire, where the liquor in it is permitted to simmer, for two or three hours. The quills are then taken out, and put on a board, to dry, before a gentle fire. After they have been dried and rubbed over with bear's oil, they become of a beautiful shining black, and are fit for use. To dye red or yellow, they make use of certain roots, and the moss which they find, on a species of the fir tree. These are put, together with the quills, into a vessel, filled with water, made acid, by boiling currants or gooseberries, &c., in it. The vessel is then covered tight, and the liquid is made to simmer over the fire, for three or four hours, after which the quills are taken out and dried, and are fit for use, . . . and these colours never fade."

As a result of many inquiries made of the old people on the Sioux reservations in North Dakota and South Dakota, it was learned that native materials for dye-making were plentiful and varied in the old days. After numerous and extended talks with groups of the older members of the tribes, some interesting notes

[1] Maximilian, Prince of Wied, Travels in the Interior of North America, 1832–34, Thwaites ed., pt. II, pp. 103–104, Cleveland, 1906.

[2] Ibid., p. 13.

[3] A Journal of Voyages and Travels, pp. 377–378, Andover, 1820.

on the old-style method of dyeing were obtained, and in some instances the materials were produced for identification. There is a possibility, however, that some of the details of the dyeing processes are forever lost.

The buffalo-berry and squaw-currant were used for producing a red dye, but the former was preferred because it is more succulent than the squaw-currant, which has a large seed with a thin skin and consequently required a greater quantity to produce the desired color. The operation of dyeing consisted simply of boiling the fruit and porcupine-quills together in water until the required color was obtained. Sometimes dock-root was used in addition to the fruit, because it produced a brighter and stronger color. Care was exercised in collecting the root, as the "mother," not the "father" plant, must be used; the difference between the two plants was recognized by the flowers.

Wild grapes were used for making black dye of superior quality, while a good substitute was found in hickory or walnuts when grapes were not obtainable. The nuts, gathered green (that is, before the hard shell had formed), were laid in the sun and occasionally sprinkled with water until they turned black, and then were boiled in water with the quills. The resultant color was a brownish-black, and consequently was not so satisfactory to the discriminating artist as that produced by the grapes.

Wild sunflower and cone flower (*Ratibida columnaris*) were used for producing yellow dye. The petals, with pieces of decayed oak-bark or the roots of cattail, were boiled in water with the quills. The bark of a certain pine tree "found only in the Black Hills" is said to have been another medium for producing yellow dye.

Blue dye seems to have been unknown, at least among the Dakota Indians, in the early days. After the introduction of aniline colors, however, blue came into use, and later, when the Government issued blankets to the reservation Indians, a piece of an old blue blanket was boiled with the quills to produce that hue.

Among the Ojibwa of Georgian bay it was learned that tamarack bark produced a red dye of medium shade, and that a darker color was obtained by using spruce-cones. Another shade of red was

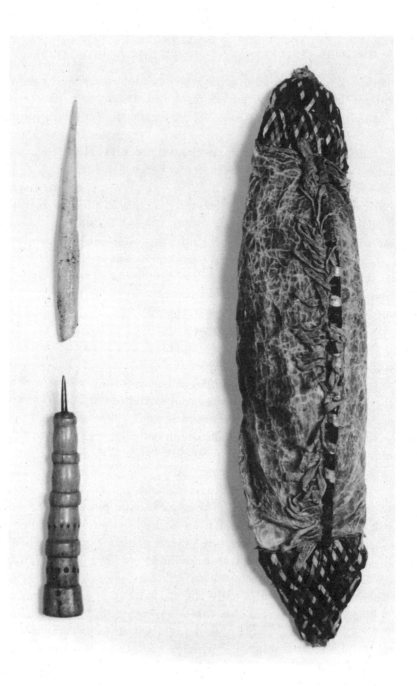

PLATE II

QUILL WORKER'S TOOLS AND SUPPLIES

AWLS. *BLADDER POUCH.*

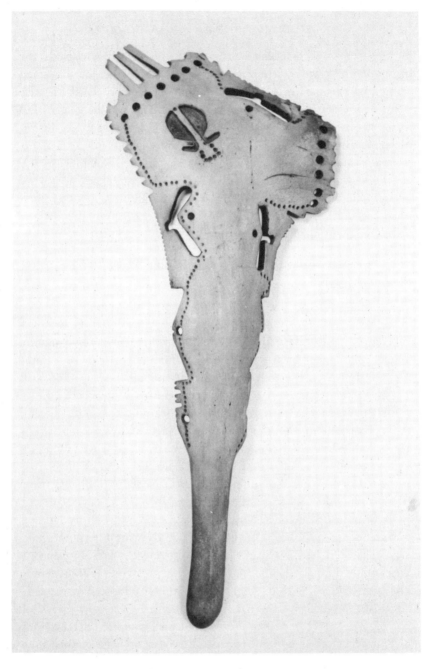

PLATE III
ANTLER QUILL FLATTENER
1/591 *HUNKPAPA SIOUX. NORTH DAKOTA* L: 14 IN.

obtained from sumac berries. Yellow dye was made from the roots of black willow, but a much brighter yellow was obtained from fox moss, *Evernia vulpina*, which was rarely used because difficult to procure. The inner bark of hemlock produced a brownish-red, but apparently was not considered a good color by the old people. Blueberries afforded a color approaching purple. Larkspur was spoken of as having been used to produce pale blue.

These few notes on dye materials were collected from four very old people, but it was not possible to obtain any details other than that the quills were boiled in concoctions made from the various products mentioned.

IMPLEMENTS USED IN QUILL-WORK

The modern artist's outfit (pl. II) is not very extensive, consisting merely of a pouch for holding the quills, a bone marker for tracing the design on the leather or birchbark, some awls, a bunch of sinew strands, and a knife. Sometimes a pair of scissors may be found in a modern outfit, but rarely a commercial needle or a thimble. It is safe to say that nearly all the modern quill-workers still use an awl and sinew without a needle to perform their work.

There is no reason to believe that the quill-workers of earlier days possessed anything more elaborate in the way of tools, unless an exception may be made of the quill-flattener, of which there are a few in existence, decorated with elaborate carvings as illustrated in pl. III . It is not certain, however, that such an implement was used commonly to flatten the quills, as it is so much easier and more practical to meet that need of the process by simply holding one end of the quill between the teeth and drawing the thumb-nail, tightly pressed, lengthwise of the quill—the method used by present-day quill-workers. Aside from this, the so-called quill-flatteners are large and somewhat cumbersome (the specimen illustrated is 14 inches long), hence their use would result in a loss of energy, if not of time, when it is considered that each quill is flattened immediately before it is used, because it would be necessary to take up and lay down the instrument many times during a day's work. Some quill-flatteners are made of bone, others of antler. A few

other objects may be found in a workbag, such as a whetstone, perhaps some patterns, and many trinkets that may not be necessary to the work in hand.

A thread of sinew was used for sewing the quills to the leather. The fiber of which this thread was made was stripped from the large tendons along each side of the backbone of the buffalo or deer. The raw tendons were dried and shredded, and sometimes twisted into hanks ready for use. A suitable strand being selected, it was moistened, one end pointed by twisting between the thumb and forefinger, and then allowed to dry. A point so treated would easily follow an awl-hole in the leather. The other part of the thread was kept soft and moist by occasionally applying saliva with the finger-tips.

This item of information was furnished by an old woman at Pine Ridge, South Dakota. Doubtless the same method of preparing and using sinew thread was employed by the early quill-workers.

James Adair, in his *History of American Indians*, says: "The needles and thread they used were fishbones, or the horns and bones of deer rubbed sharp, and deer sinews, and a sort of hemp that grows among them spontaneously in rich, open lands."

Designs were laid out with the aid of cut patterns, sometimes made of rawhide or birchbark, or were drawn freehand. The marker, a thin, flat piece of bone, three or four inches long by one inch wide, with smooth, rounded edges, was used as a pencil to follow the cut pattern, or, without such guide, was dipped in a dark-colored fluid, or the marks were made by simply rubbing the edge of the bone on the leather, which left a mark not easily erased. In this part of the work the women oftentimes were aided by suggestions from the men.

Material for making a "dark-colored fluid" was collected on the Pine Ridge reservation, South Dakota, and is part of a very old painting outfit which consists of bone marker, pieces of wedge-shaped bone pith used for applying the color, and various earth colors, including a fine, soft, black powder, described as being "mud from a river-bottom a long way off to the northwest." Ac-

cording to my informant, many years ago this black mud was obtained by trading with the Indians from the northwest, and was in great demand for marking out patterns and for picture-writing on skins. A solution was made by mixing the dried mud with water. Sometimes a small quantity of blood was added as a binder.

STITCHES

Several kinds of stitches are used in fastening the quills to the leather, which for convenience in description I have named as follows:

Spot-stitch—The first and most simple is spot-stitch (fig. 2). In the drawing it will be seen that the sinew thread passes straight ahead, and is spotted through the surface of the leather at regular

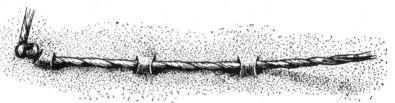

FIG. 2.—Spot-stitch.

intervals, the exposed part of the sinew forming a loop which holds the quill. It can easily be seen that such a stitch can follow a curved line.

Back-stitch—The second I have designated back-stitch (fig. 3). In this case, in sewing from left to right, the awl is thrust through the surface of the leather with the point inclined toward the left and pointing upward. When the sinew is drawn tight, the fibers of the leather are caused to twist and grip the sinew, so that the stitch cannot slip. The stability of this stitch was apparently fully realized by the Indian artist, as it is found in most of the specimens of early work, and is used to some extent by recent workers.

Loop-stitch—The third may be called a loop-stitch (fig. 4). An incision is made through the surface of the leather by pointing the awl upward. The sinew is passed through the opening in the same direction as the awl was made to take, then made to cross itself

and passed on to the next incision, when the operation of passing through the leather and crossing is repeated. It may be understood from the drawing that a stitch so formed with a moistened

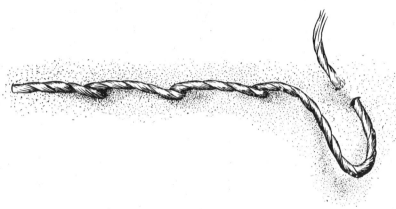

FIG. 3.—Back-stitch.

sinew thread, when pulled tight, cannot possibly slip, but makes a firm and lasting stitch.

A remarkable feature in porcupine-quill work is that even in the very oldest specimens examined the stitches had rarely pulled out, although the quills may have been worn away and perhaps

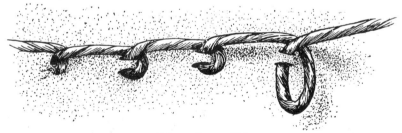

FIG. 4.—Loop-stitch.

the exposed sinew had worn off, but the ends still held fast in the leather.

A point of interest in connection with the sewing, which will be well to emphasize at this time, is the fact that the stitches were never carried through the leather from back to front, but we

caught only under the surface, even when very thin deerskin was used. The reason given for this, by an old woman on the Crow Creek reservation, who at the time of my inquiry was embroidering a large pouch, was, "that it is hard to guess where to push the awl through from the under side without turning the piece of leather over." There is no doubt that the position for the stitch can be more readily found by working from the upper side, especially where a large surface is being decorated. Also a much finer stitch can be made when the thread is passed through the surface only. Sometimes a knotted end of the sinew may be found on the reverse side.

<div align="center">SPLICING</div>

Owing to the shortness of porcupine-quills, it became necessary to formulate a system of splicing, or inserting additional quills, in such manner that the ends should be secure and concealed. A common method seems to have prevailed among all quill-workers. To facilitate the explanation of the numerous techniques employed in the art of quill-work, the splicings will be described at this time; and unless otherwise stated it may be understood that these methods have been made use of in the work hereafter to be treated.

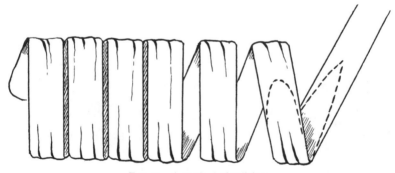

<div align="center">FIG. 5.—A method of splicing.</div>

A very simple though effective splice, illustrated in figure 5, is made use of in a majority of the techniques. As the drawing shows, when the end of a quill has been reached in embroidering, a new quill is added and secured by laying its point inside the fold of the last quill, where a stitch is made across the overlapping

extremities. The dotted lines in the drawing indicate the positions of the two ends. This splice has remarkable holding quality, in some measure due to the fact that the quills were moistened and flattened when being used, thus rendering them soft and pliable; after they became dry they were stiff and could not change their position. This splice has been employed in the braiding used for pipe-stems, etc., described in connection with figures 32 and 33.

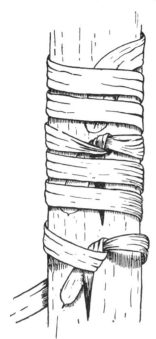

FIG. 6.—A method of splicing.

In making a splice where a strand of fringe or some slight object has been wrapped with porcupine-quill, the two ends were twisted and turned under the wrappings (fig. 6). Such splices are always found on the back of the object so decorated, or as much out of sight as possible, the front or better side showing a continuous and even wrapping.

One other method has been observed, although not a very common one, which may be called "telescoping," that is, the point of an added quill has been thrust into the end of the preceding one (fig. 7). This mode of splicing has been found only where unflattened quills have been used.

Of the various methods employed in fastening the quills to leather, where broad masses of solid embroidery are desired, the most simple form seems to be that shown in figure 8. As may be seen in the drawing, the spot-stitch is here used. The quills are held in place by two rows of stitches, the sinew thread being caught into the surface of the leather between each fold of the quills. Such

FIG. 7.— Splicing by "telescoping."

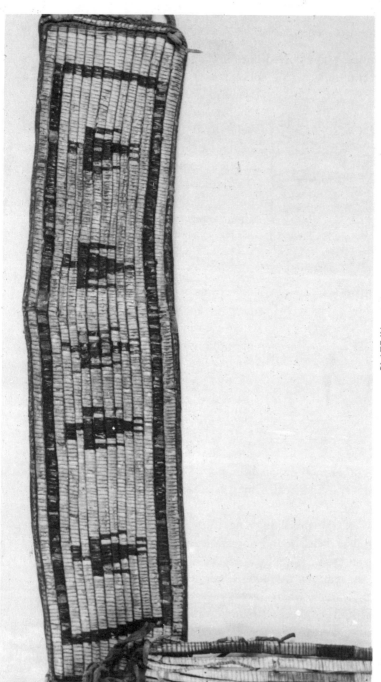

PLATE IV

QUILLED ARM BAND; FROM A WAR BUNDLE

2/8591 SAUK AND FOX. KANSAS 2¼ x12 IN.

bands of embroidery vary in width from one-eighth to five-eighths of an inch, or in rare instances to three-quarters of an inch, and are worked side by side until the desired area is covered.

Should the space to be decorated be other than square or rectangular, as for instance the toe of a moccasin, the lines of stitches

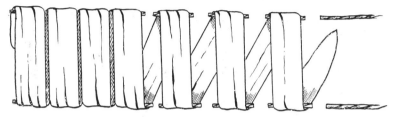

Fig. 8.—Method of fastening quills to leather.

and folds of the quills converge, so as to conform to the shape of the area. By the use of contrasting colors, geometrical designs have been worked out. In some instances the effect has been elaborated by a widening or contraction of the rows of quill-work. An interesting addition to this method has been noted on some recent Hidatsa work (fig. 9), in which stitches have been made along the center of the rows or bands of quill-work over the surface. As

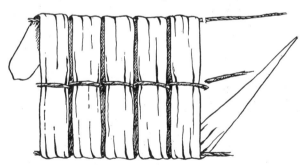

Fig. 9.—Hidatsa quill-work with stitches along center.

the bands are not so wide as to demand such sewing for strength, it is probable that additional ornamentation was the object in view. The extra stitch is the back-stitch.

According to observations made among modern quill-workers, it was found that such bands of quills were worked from left to

right. The lines of the bands having been drawn on the article to
be decorated, a sinew thread is made fast at the respective starting
points of both rows of stitches; a quill is then laid in the first position
at the top of the band, a stitch is made over that end, and the quill
is turned over the stitch, when another fold is made at the proper
distance to conform to the width of the band. The sinew thread at
the lower line is now passed through the fold and caught into the
surface of the leather as close to the quill as it is possible to get it.

It will be seen from the drawing (fig. 8) that in the last men-
tioned folding, at the bottom of the band, the quill is folded under
itself, and then passes on diagonally across the band to the next
position at the top, where another fold and a stitch are made.
The distance between the folds has been exaggerated in the drawing
in order to show the movement of the quill, which if drawn correctly
would be obscure.

There are a number of instances in which a strip of rawhide
has been used as a filler, that is, the quills have been wrapped
around the strip, and the stitches made in the usual place where
the folds in the quills have been made, as shown in figure 10. This
method seems to have been used to some extent by the Haida and

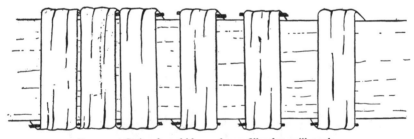

FIG. 10.—Strip of rawhide used as a filler for quill-work.

Tsimshian. A specimen of the same technique, however, has
appeared on an arm-band in a very old war-bundle collected from
the Sauk and Fox Indians, illustrated in plate IV.

In consequence of having the strip of rawhide under the quills,
the work does not have that close, compact appearance so noticeable
when the strip has not been used. The arm-band has been further
ornamented with an elaborate fringe fastened to one end, com-

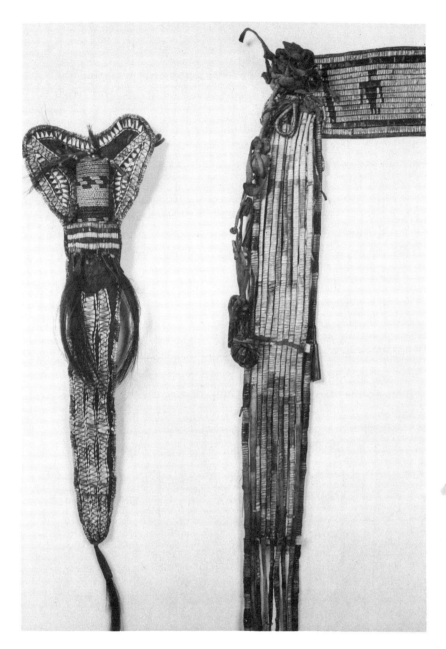

PLATE V

QUILLED KNIFE SHEATH AND HANDLE DETAIL OF FRINGE OF ARM BAND

4/901 DELAWARE L: 11 IN. *2/8591 SAUK AND FOX*

posed of eleven strips of rawhide wrapped with porcupine-quills in
the manner described for figure 6. The fringe was originally
decorated with three, perhaps four, human figures. The design
is produced by the introduction of various colored quills at measured
intervals. The figures are about three and one-half inches long,
and in the center of each body a short wrapping of bird-quill has
been applied.

Plate v, *b.* , illustrates a section of the fringe showing two figures;
there are indications of the third, but the condition of the specimen
is such that the presence of a fourth figure is not at all certain.
The specimen is a well-executed piece of the decorated fringe
technique.

Although the spot-stitch is so simple, it does not appear to have
been used so commonly as the back or loop stitches, and in all
probability the better holding quality of the two last named stitches
was fully appreciated. A majority of the specimens of quill-work
examined, in which bands of embroidery have been used, show
the use of the back-stitch or loop-stitch; and sometimes both
stitches have been used on one band, that is, the top edge is held by
the loop stitch while the lower is held by the back-stitch.

The modern quill-workers have introduced another thread in
connection with these bands of embroidery, one which I have been

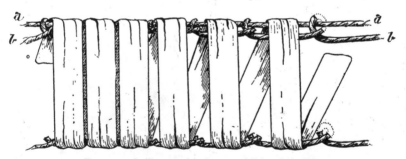

Fig. 11.—Quill-work showing an additional thread.

unable to find in any of the old specimens. In figure 11 the added
thread is marked *a*. The loop-stitch is always used with it, and
the additional thread is employed only along the top edge of the
band. In connection with this, a fact to be noted is that I have

never found anything but a commercial thread used for that marked *a*.

The illustration shows the two threads *a* and *b* starting off together at the upper edge of the band, after being knotted into the leather. A turn of the quill is made, and then follows a loop-stitch by thread *b* through the leather and over thread *a*. At the lower edge a stitch and a fold of the quill are made, when the first operation at the upper edge is repeated, and so on until the band is completed. While the sewing is proceeding, the thread *a* is kept taut by having the end not fastened to the work wrapped around a small stick which is tucked into the quill-workers' moccasin. Being thus held, the thread can be tightened or slackened as required.

No satisfactory explanation of the function of the extra thread could be obtained from the many quill-workers with whom I came in contact. One woman explained that by drawing the thread tight under the fold, "it made the quill lay flat and close to the leather." Another said, "That is the proper way to do the work;" still another explained that "it was only a fashion," and that just as good work could be done without the extra thread. This last statement is a truth which may be well substantiated by comparing modern work with specimens of earlier days. The use of the additional thread is found not only in broad bands making up solid masses of embroidery, but is invariably made use of in narrow bands such as is shown in plate VI, which illustrates a small calfskin with nineteen bands of embroidery, each band one-eighth of an inch wide, every one of which is sewed to the skin with two rows of stitches including the linear thread. It may be readily understood that a great amount of patience must have been exercised in performing such work.

Figure 12 illustrates an entirely different effect, produced by a change in the method of folding the quills. Compared with figure 8 it will be seen that the quill coming from the upper edge passes under the stitch at the lower edge of the row, and, crossing diagonally to the upper edge, passes under the stitch at that point, then turning over itself toward the lower edge, makes an interlocking saw tooth pattern, instead of the parallel bars shown in figure 8.

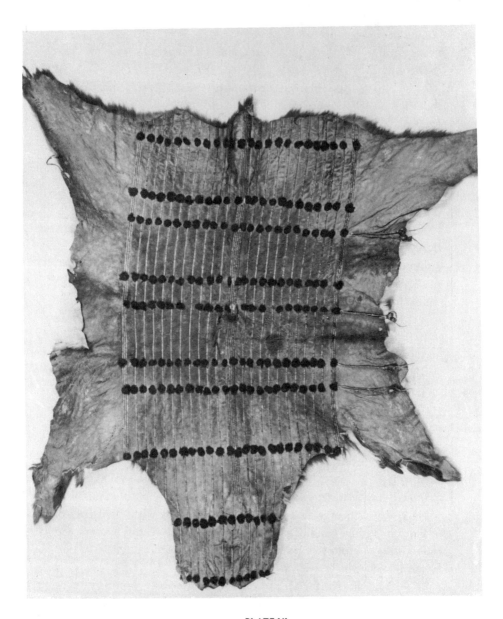

PLATE VI
CHILD'S QUILLED BUFFALO HIDE PUBERTY ROBE
8/1209 SIOUX. SOUTH DAKOTA 26x39 IN.

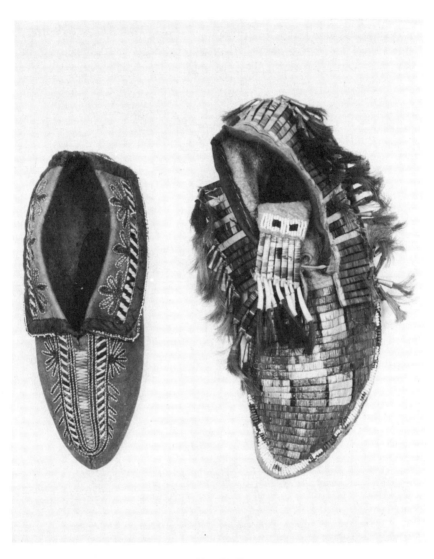

PLATE VII
QUILL DECORATED DEERSKIN MOCCASINS

1/1141 SENECA. NEW YORK L: 9¾ IN. 8986 SIOUX. SOUTH DAKOTA

An interesting variation of this process is illustrated in figure 13. As the drawing shows, two quills have been used, the diagonal crossings extended and the quills overlapping those crossings alternately. The folding is practically the same as that shown in figure 12, but the overlapping of the added quill has produced a

FIG. 12.—A method of folding the quills.

surface pattern of entirely different appearance. A striking effect is produced by the use of quills of contrasting colors.

The methods of folding illustrated by figures 8, 12, and 13, are those used in single-band decoration or in covering broad surfaces. Designs are introduced by the use of variously colored quills or by

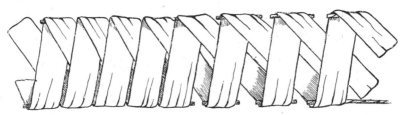

FIG. 13.—A method of folding the quills.

changing the position and the widths of the rows. The designs produced by this technique are of a geometrical nature, a good example of which is shown in plate VII.

An intricate method of crossing and folding is shown in figure 14, the details of which may be clearly traced. The specimens on

which this technique occurs consist of two snake-skins, found in an
Iowa war-bundle. They are decorated on one side only, and but
a short length of the surface is covered. Three rows of the quill-
work were laid side by side (the drawing shows only two). Red
and yellow quills were used, and so folded that the yellow quills
form a diamond-shaped pattern across the whole embroidery, the
red quills producing a smaller diamond enclosed in the yellow
pattern. The drawing shows the quills spread apart abnormally,
but when drawn close together a solid, well-defined pattern is the
result. Spot-stitches are looped through the turn of the quills

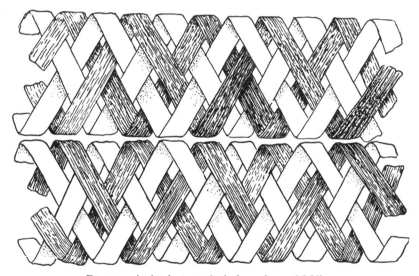

FIG. 14.—An intricate method of crossing and folding.

at each fold along the edges of the row, and splices are made in the
usual manner. A section of a decorated snake-skin is shown in
pl. VIII. The design suggests the natural markings of the skin.
 Other methods of covering large surfaces are shown in figures
15 and 17. In figure 15 is introduced a technique similar to the
checker weave of basketry, consisting of two elements crossing
each other at right angles, one over and one under. This form of
decoration is found usually where rectangular or square areas are
covered. The arrangement of the quills in this technique precludes

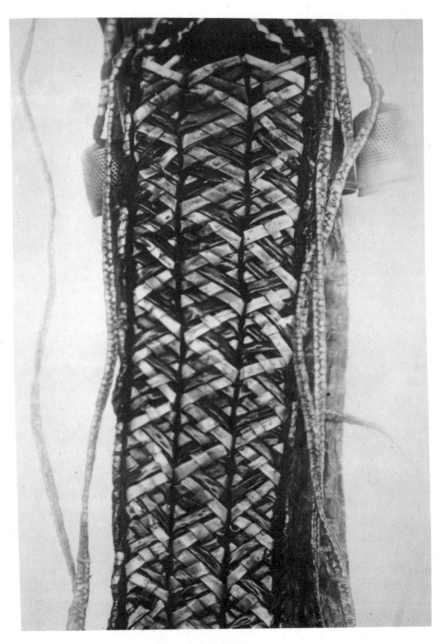

PLATE VIII
QUILL DECORATED STRIP FROM A WAR BUNDLE
IOWA. OKLAHOMA

the possibility of working out designs to any extent; however, some attempt has been made by using quills of different colors. The quills are held in place by spot-stitches around the edges of the decorated area, where the ends of the quills are turned under, indicated by dotted lines in the drawing. Sometimes the width of

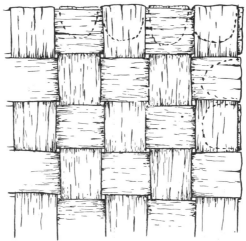

FIG. 15.—The "checker-weave" method of covering large surfaces.

the area has proved to be greater than the length of a quill; in such cases the ends and points of added quills are concealed under crossing elements. An example of this work is shown in plate IX. The specimen illustrated is a section of a decorated legging of Blackfoot origin.

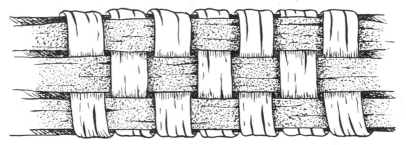

Fig. 16.—Another form of the "checker-weave."

A wrapping of the same technique is found on strips of rawhide about one-quarter of an inch in width (fig. 16). In this case no

stitches are used to keep the quills in place; instead, the ends of the crossing elements are twisted together at the back of the rawhide strip, as shown in figure 6, while the ends of the quills laid lengthwise are held in place by wrappings of sinew at the extremities of the rawhide strip. Splicing is accomplished by overlapping the ends of the quills, which are secured and concealed by the crossing elements. The form of decoration here described has been applied to the entire length of an eagle-feather, fastened to the quill, and worn as a scalp ornament of Osage or gin.

Figure 17 illustrates what may be called a plaiting, where two elements cross each other obliquely over and under, forming a

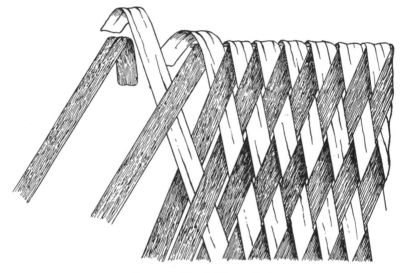

FIG. 17.—The plaiting method.

diamond-shaped pattern. The quills are held in position by spot-stitches around the edge, and, when necessary, across the decorated area where that is wider than the length of a quill. This technique has been found in broad patches (from seven to ten inches wide) on pipe-bags and baby-carriers. The same method of splicing as described in the preceding technique is employed.

Little opportunity is given for working out designs other than those that are strictly geometric. A very pleasing effect of this

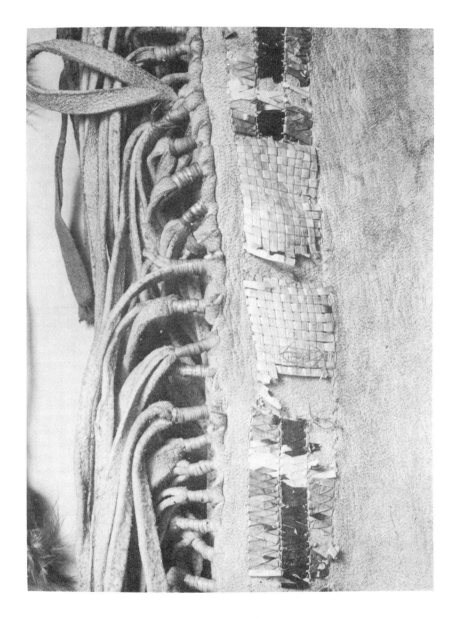

PLATE IX
SECTION OF BLACKFOOT LEGGING
SHOWING DETAIL OF CHECKER-WEAVE TECHNIQUE
1/4445 MONTANA

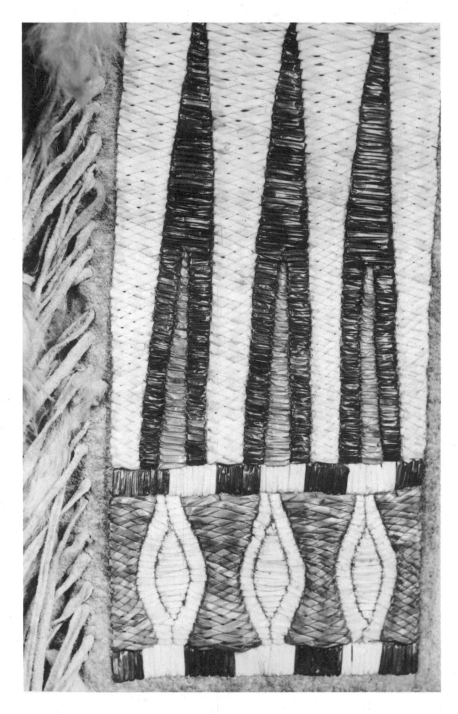

PLATE X
QUILL WORK DECORATION ON A BUCKSKIN SHIRT; DETAIL
12/2160 TETON SIOUX. NORTH DAKOTA W: 3 IN.

technique is produced by the working of narrow bands (fig. 18) side by side, an example of which may be seen on plate IX, above and below the checker weave on the section of Blackfoot legging. The drawing shows the use of two quills which are made to cross

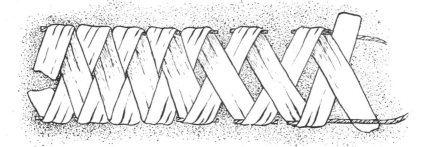

FIG. 18.—Technique produced by working narrow bands.

each other diagonally, forming a single diamond pattern in the center of the band. Figure 19 shows, by the addition of a third quill, how a double-diamond effect is produced. This is illustrated in the long, pointed pattern on plate X.

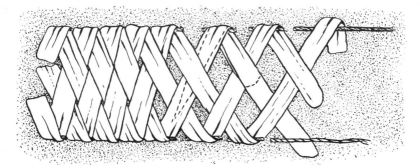

FIG. 19.—Double-diamond effect produced by the addition of a third quill.

An entirely different effect is produced in the appearance of a narrow band (fig. 18) by introducing quills of contrasting colors. For example, in figure 20 black and white quills are shown, with exactly the same folding as used in figure 18, resulting in black and white lines running diagonally across the band. This variation

occurs frequently and unless closely examined has the appearance of being a different technique. Examples of it are shown in plate XX.

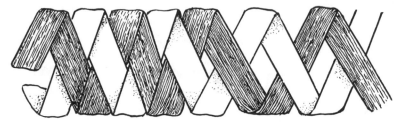

FIG. 20.—Effect produced by using black and white quills.

Figure 21 illustrates an unusual method employed for bringing together two quills of contrasting colors; in fact it is the only specimen I have found in which two quills have been used one on top of the other. A white quill is backed with a black one; then the two are worked along together and folded in such manner that first a white surface is exposed, then, crossed by another fold, a black surface is presented, the whole producing a sawtooth pattern.

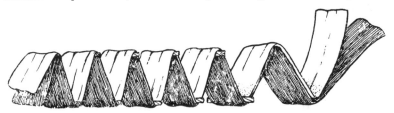

FIG. 21.—Use of superimposed quills of contrasting colors.

This interesting technique occurs on a knife-sheath collected many years ago from the Delaware Indians; it was recently found in Europe, and has since been added to the collections of the Museum of the American Indian. The sheath is made of black tanned deerskin, and is profusely although rather crudely decorated with porcupine-quills. The specimen is shown on plate v, *a*. The technique referred to may be seen at the top, on the broad part, behind the knife handle.

Figure 22 exhibits a method employed by the Tlingit to cover broad surfaces with porcupine-quills. The quills are laid length-

wise, and side by side on the object to be decorated. Spot-stitches are concealed beneath the ends of the quills, which are turned under. At regular intervals a stitch is made across the surface of the quills. The first is caught into the leather under the quill on the outside edge of the band of decoration, then passed over the next quill and into the leather beneath the third quill, alternating across the entire width of the band. The second row of stitches is commenced by crossing the surface of the first quill, under the

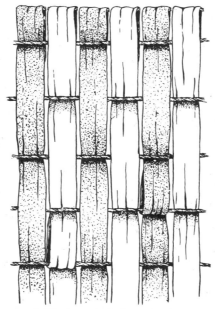

FIG. 22.—A Tlingit method of covering broad surfaces.

second, over the third, and so on. The splicing of additional quills is accomplished by turning the end of the nearly used quill under the nearest cross-stitch, and laying the end of the new quill under that stitch.

A head-band and several similar specimens are in the collections of the Field Museum, Chicago. The drawing (fig. 22) represents the work somewhat spread apart. A pleasing effect is produced by this technique, especially when quills of contrasting colors have been used.

A form of weaving is introduced in figure 23. Attention must here be called to the fact that in the drawing the work is greatly spread apart to show clearly the direction taken by the component elements. The warp-strands are of twisted sinew or some vegetal fiber, the ends of which are knotted into the leather to be decorated. The flattened quills, which form the weft, are passed over and under the warp strands, each row of quills beginning with the same warp element as the row above it; that is to say, the rows do not alternate. If left in this condition the work would fall apart; therefore, to hold the weave together, another strand of sinew or fiber has been woven in between each row of quills, crossing the warp-strands over and under where the quills have crossed under

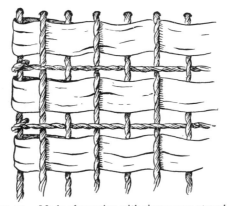

FIG. 23.—Mode of weaving with sinew warp-strands.

and over. The end of this added strand is knotted to the first warp element, and then at regular intervals spot-stitched into the leather. In this technique the elements are all drawn together so that the threads going in the same direction as the quills are seen only under very close examination.

A beautiful specimen of this work (pl. XI) was collected in Alaska for the United States National Museum. The same technique is to be found on a deerskin garment of Athapascan origin in the Field Museum.

Still another method of covering broad surfaces with quill-work is shown in figure 24. Two strips of rawhide are laid parallel

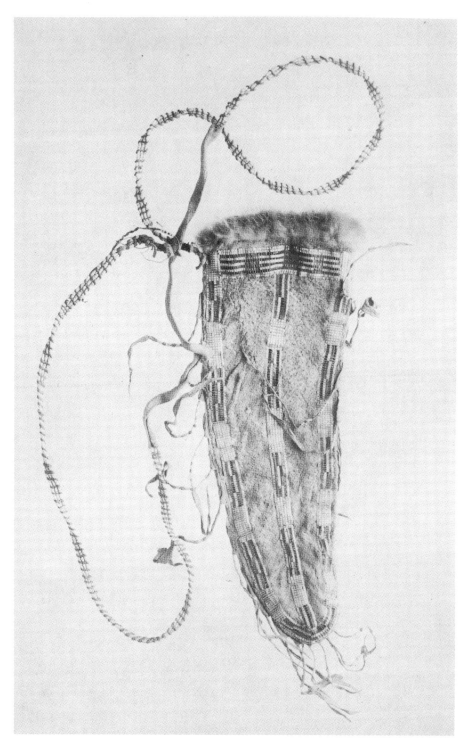

PLATE XI
KNIFE SHEATH FROM SOUTHERN ALASKA
UNITED STATES NATIONAL MUSEUM

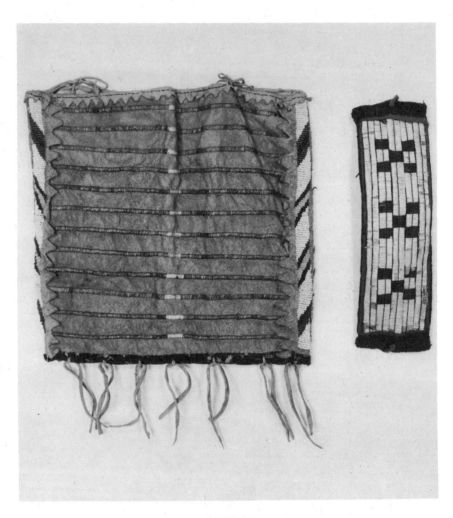

PLATE XII

QUILLED POUCH QUILLED DANCE ANKLET

12/2280 TETON SIOUX 9½x9½ IN. 18/4382 HOPI. ARIZONA L: 8 IN.

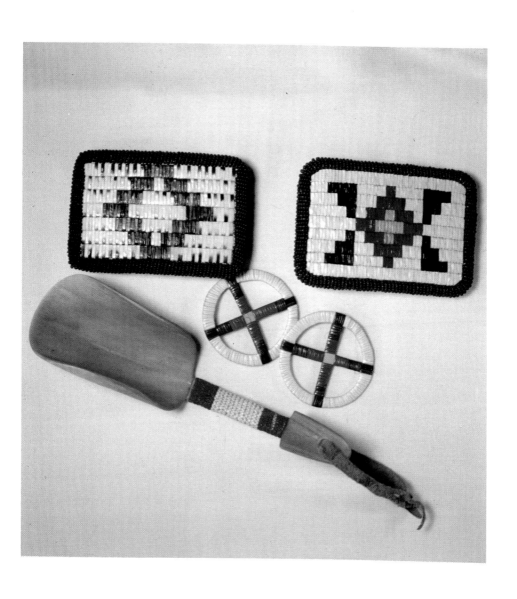

PLATE XIII
CONTEMPORARY ROSEBUD SIOUX
QUILL WORK

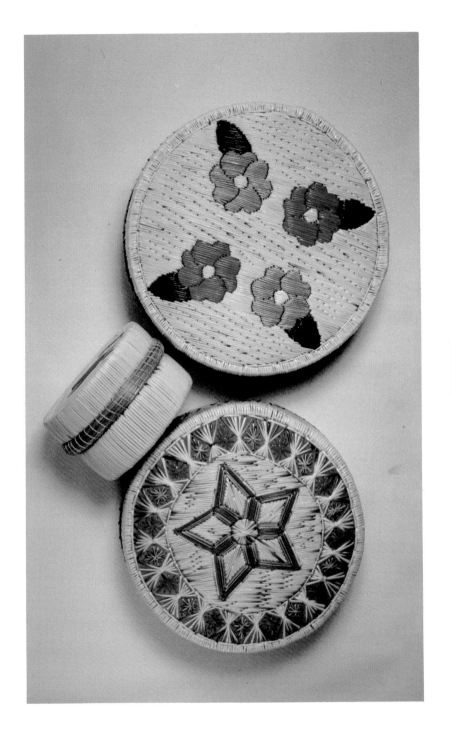

PLATE XIV

CONTEMPORARY QUILLED BIRCHBARK BOX

OJIBWA

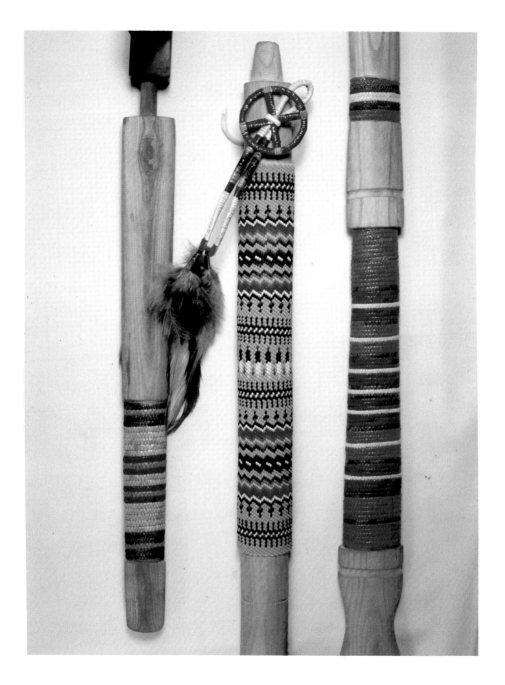

PLATE XV
CONTEMPORARY ROSEBUD SIOUX
QUILL WORK

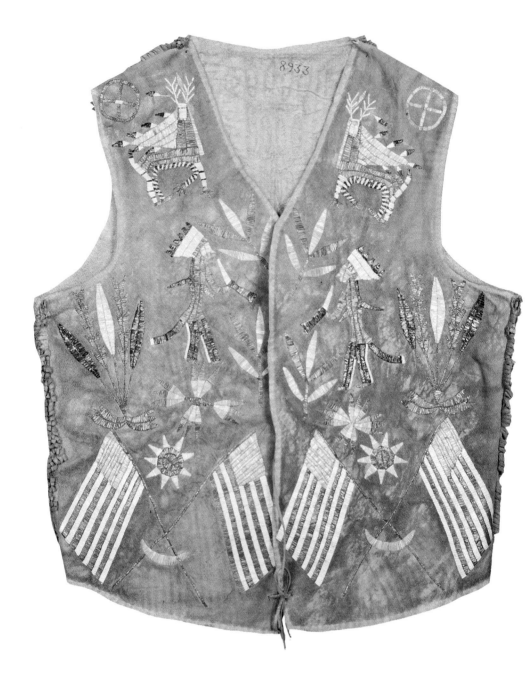

PLATE XVI
MAN'S QUILLED BUCKSKIN VEST
OGLALA SIOUX, SOUTH DAKOTA. *CA. 1880*

and wrapped with flattened quills, which are held in position by a twisted sinew thread passing alternately over and under the quills, between the rawhide strips. The quills, having been softened by moisture, are easily crowded together by drawing the thread tight, thus forming a compact wrapping, entirely concealing the rawhide strips. Various widths are found, ranging from about one-quarter to five-eighths of an inch. Such strips are laid side by side and

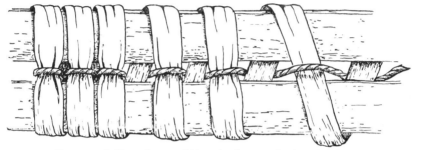

FIG. 24.—Quill-work on rawhide strips for covering broad surfaces.

sewed to the article to be decorated by passing stitches through the loops of the quills on the under side of the strips. The number of strips used and also the length are governed by the size of the area to be decorated. This technique has been made use of by the Tlingit and by some neighboring tribes, but not to a great extent.

Some attempt has been made to introduce designs by changing the color of the quills at measured intervals.

With variation, specimens of this technique have been collected from some of the Pueblo Indians, the difference being in the use of two threads instead of one to bind the quills to the rawhide strips. Figure 25 shows the two threads with a twist between each loop of the quills; in other respects the work is carried out just as it is by the Indians of the northwest coast. Plate XII, *b*, illustrating an anklet made by the Hopi of Arizona, shows the method of working out designs. The difference in the work of such widely separated peoples can be detected only after very close examination. The usual method of splicing and of supplying additional quills has been observed in this technique.

Pl. XVII illustrates a highly ornamented circular form of decora-

tion. Such discs of quill-work are found on buffalo-robes, medi-
cine-bags, etc., and have occurred as tipi ornaments, in which
latter case they have been made detachable, not sewed directly
to the material of which the tipi-cover was made. The specimen
illustrated was to all appearances originally made for a tipi orna-
ment and was subsequently used to decorate a medicine-bag. It
may be seen that the quill-work is sewed to an independent piece of
deerskin, and then sewed to the bag over some bead-work. Plate
XXII shows this form of decoration sewed to a quiver. The technique
may be called a wrapped coil, but the coils are not sewed together
as in the case of coiled basketry. The filler, or foundation, of the
coil is composed of horse-hair in modern work, but in one or two

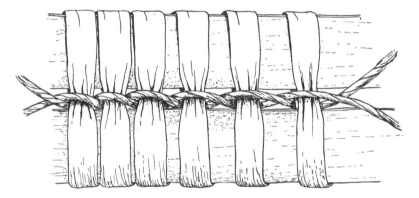

FIG. 25.—The use of two threads for binding the quills.

very old specimens examined the filling has the appearance of
human hair, and in others the long hair from a buffalo-tail. A
hank of hair of sufficient size to form a coil of the required diameter
is wrapped with moistened and flattened quills as shown in figure
26, and through alternate loops of the quills, stitches are carried
into the leather forming the base or groundwork of the decoration.
It is very evident that the wrapping, coiling, and sewing were
manipulated together, especially where a design has been intro-
duced, otherwise the alignment of the pattern would be imperfect.
 A buffalo-robe of Blackfoot origin in the Museum of the Ameri-
can Indian has been decorated with four discs of this technique,

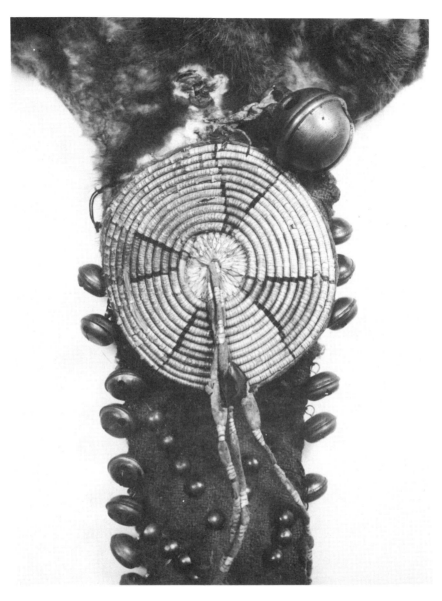

PLATE XVII

QUILLED CIRCULAR ORNAMENT FROM A MEDICINE POUCH

10/3086 IOWA. OKLAHOMA D: 3¾ IN.

and in addition to various colored quills to produce a design, wrappings of black horse-hair and a fine cord made from vegetal

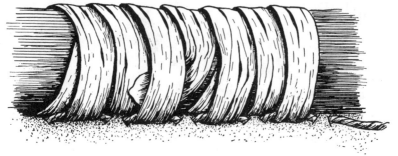

FIG. 26.—Quill-work on a coil of hair.

fiber have been employed, probably to give a touch of variety to the ornamentation. Another form of wrapped filler decoration is shown in figure 27, the general appearance of the ornamentation of which would suggest the same technique as described for figure 26. There is, however, a wide difference in the manipulation of the materials used. Instead of one hank of hair, two are employed. The quills are wrapped around both hanks, and, as the wrapping proceeds, stitches are made over the quills, between the rows and into the object being decorated. The stitches are drawn so tightly that they are entirely concealed. This technique has been used in the form of broad bands, eight or ten or even more being laid lengthwise side by side, serving as shoulder-straps reaching to the waist-line on a deerskin shirt, also as bands on the sides of leggings. So far this technique has not been found in any form other than straight lines. Specimens of this technique have been collected from the Sioux, Nez Percés, and Mandan.

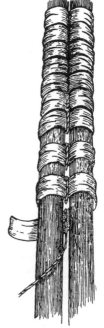

FIG. 27.—Another form of wrapped filler decoration.

Pipe-stems, club-handles, and occasionally horn spoon-handles

have received their share of attention so far as ornamentation is concerned. Various methods have been employed for that purpose. The most simple manner of fastening porcupine-quills to a rounded stick, such as a pipe-stem, was recently brought to light by Dr F. G. Speck while conducting ethnological investigations among the Penobscot Indians of Maine. An old woman of that tribe was induced to make a specimen of quill-work, other than that on birch-bark, which she remembered from childhood. The specimen produced, without any aid in the way of suggestion, was the pipe-stem shown on pl. XVIII, *c.* The back or under side of the stem is seen in the illustration; the front, of course, presents a series of

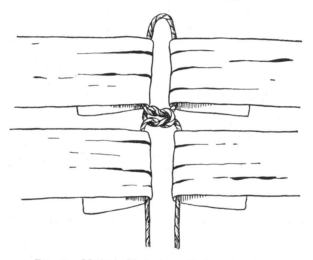

FIG. 28.—Method of fastening quills to a pipe-stem.

unbroken wrappings. The quills are wrapped around the pipe-stem once; the ends are turned under where they meet at the back of the stem and are held by a cord passing through each of those under-turned ends, and the cord is tied between each wrapping. Figure 28 illustrates the method of fastening the quills to the pipe-stem. Pipe-stems with similar wrappings have been collected among the Plains Indians and also from Woodland tribes, but the handling of the fastening cord in most cases has been different.

Figure 29 shows a rather complicated method of tying. The

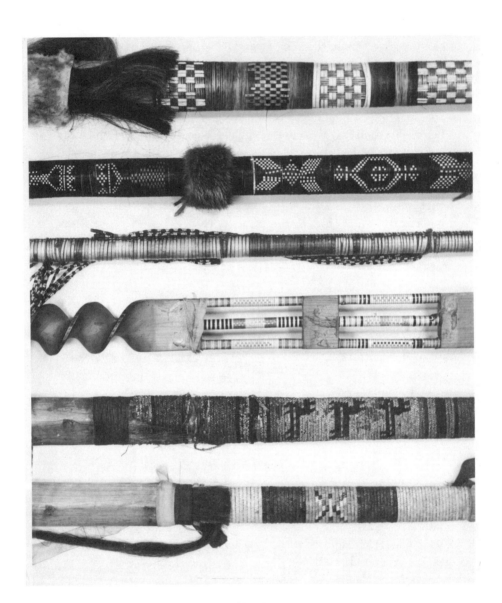

PLATE XVIII
WOODEN PIPE STEMS WITH QUILLED DECORATION

16/2537	16/6904	10/4110	10/3502	2/3334	24/1122
BLACKFOOT	FOX	IOWA	MIAMI	MANDAN	BRULE SIOUX
MONTANA	IOWA	OKLAHOMA	INDIANA	NORTH DAKOTA	SOUTH DAKOTA

drawing perhaps will suffice without further description. In connection with this method a channel was cut lengthwise of the stem into which the cord was sunk, giving to the work a very neat finish.

Pl. XVIII, *e*, illustrates another wrapped pipe-stem, and figure 30 shows the manner of tying. In this case the ends of the quills are not turned under, but are laid over a large cord running lengthwise of the stem; a finer cord is doubled and looped under the large cord; a fine thread is passed under the larger one and is made to cross over the ends of the quills on each side of the large cord. Between the wrappings the fine thread crosses itself under the large cord before passing over the next wrapping. After the last quill is fastened, the loose ends of the fine cord are tied and the

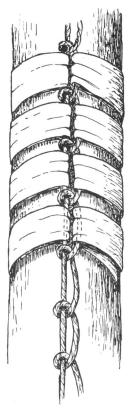

FIG. 29.—Method of tying quills to a pipe-stem.

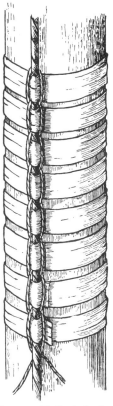

FIG. 30.—Method of tying quills to a pipe-stem.

knot crowded under the last quill, out of sight. The ends of the quills are cut off close to the binding string.

In connection with this form of wrapping, figure 31 indicates still another method of securing the quills. This decoration was found on the legs of an otter-skin which had been made into a medicine-bag collected among the Iowa Indians. At the beginning and finish of the work the cord was knotted and the knots con-

cealed under the quills. A similar decoration, with the same fasten-
ing, is found on a cord called a "slave tier," of Winnebago origin,

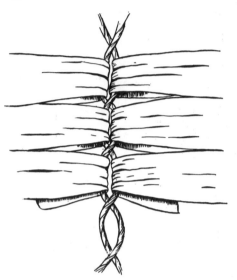

made of twisted buffalo-
hair covered with soft-
tanned deerskin and
wrapped with porcupine-
quills.

A very elaborate and
complex, and the most
common of all forms of
decorations for pipe-
stems, is shown in plate
XVIII, *b, e, f.* Beautiful
effects are produced in
this technique, and our
illustration does not do
justice to this particular
branch of the art of por-
cupine-quill work. The

FIG. 31.—Method of securing the quills.

wrapping in this case may properly be called a plaited band, com-
posed of two strings made of twisted sinew over which porcupine-
quills are braided in the manner shown in figure 32. The drawing
represents the use of one quill in this braid, while reference to

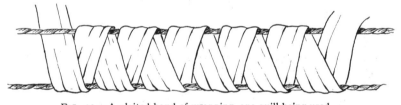

FIG. 32.—A plaited band of wrapping, one quill being used.

figure 33 will show the use of two quills. Both techniques are
found on pipe-stems, etc., but that with one quill is by far the
commoner.

From personal observation it has been found that the method
employed by modern quill-workers (and there is no reason to sup-
pose the earlier artists made use of any other) is to prepare two

long sinew threads without knots, which is done by twisting strands of sinew together just as ordinary string or twine is made. These strings must be of sufficient length to complete the decoration. Knots or an uneven surface are apt to mar the neatness of the work.

The quill-worker, seated on the ground, with legs extended, makes two or three turns of the threads around the pipe-stem, or the first turn is overlapped by the succeeding ones for security. The threads not in immediate use are wrapped around a small stick, which is thrust into the opening of the worker's moccasin or is stuck into the ground directly in front of her, for the purpose of keeping the strings tight as the work progresses. Then with

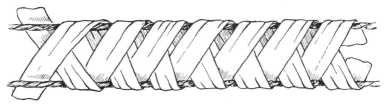

FIG. 33.—A plaited band of wrapping, with two quills.

the pipe-stem, or other object, held at a right angle to the direction in which the strings are stretched, the quills are worked over and under the strings as the drawing indicates. When a sufficient length has been plaited, it is wrapped around the object, at the same time covering the first wrappings of the sinew thread. Two or three turns of the threads on the small stick are taken off and the plaiting proceeds. When a pattern is to be introduced, quills of various colors are inserted at intervals, the distance being determined by laying the braid on the pipe-stem, and the position on the strings noted where the change of color is to take place. The lines of the plaiting may be easily followed in the illustration, which shows the introduction of quills of contrasting colors in their correct positions to produce the design. Some of these braids—the product of early workers—measure only one-sixteenth of an inch in width; modern work is rarely so fine, often measuring an eighth of an inch or more in width.

For a secure finish, the ends of the sinew threads are tucked

under the last few wrappings of the braid. Splicing is performed in the manner elsewhere described. Modern workers make use of commercial thread in place of sinew.

In connection with this technique, mention should be made of a head-band in the Museum of the American Indian, the work of the Karok of California, consisting of a string of plaiting about twelve feet long and three thirty-seconds of an inch wide, simply coiled. The plaiting shows practically the same treatment of the quills as

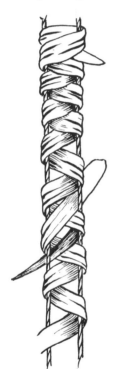

FIG. 34.— Method employed in a long string of plaiting.

is to be found on pipe-stem decorations, except that, where additional quills have been inserted, instead of the usual method of lapping, the end of the added quill has been passed under one of the sinew threads, between the last turn of the used quill (fig. 34); the end of the used quill is in like manner held by the turns of the added quill. As the plaiting proceeded, the quills were brought together tight and close so that the ends could not work loose. The ends were turned in one direction, that is, toward the back of the braid, and were cut off so that they are hardly visible.

In a similar braid, from the Ojibwa of Manitoulin island, the securing of additional quills was accomplished by telescoping (see fig. 7).

Figure 35 represents a purely woven technique in which sewing is not resorted to at all in the work, except when the weave is finished, when it is sewed to a strap of leather for use as an arm-band or a head-dress, or some other object to be decorated. For convenience, in the drawing three warp strands (*a*) are shown lengthwise of the weave, and two rows of quills, which perhaps are sufficient to illustrate the method employed in this interesting technique. Under ordinary circumstances many more warp strands are used in making up such a piece of work. For

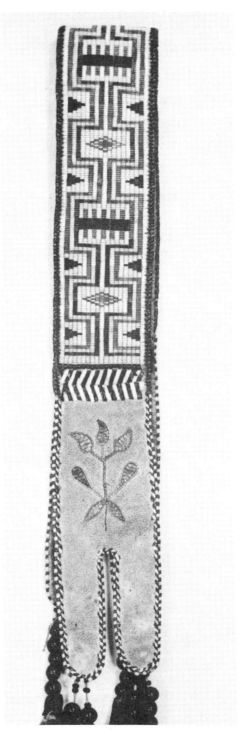

PLATE XIX

QUILL DECORATED ARM BAND

3/4649 CHIPEWYAN. MACKENZIE DISTRICT, CANADA 1½ x11 IN.

instance, examination of the specimen illustrated on plate XIX discloses the use of twenty such strands, which may be considered rather the minimum than otherwise. This specimen is about one and one-quarter inches wide. Sometimes bands of this work are several inches in width.

The process of weaving consists first of making the warp strands of either sinew or vegetal fiber, which are stretched side by side their entire length on a bow, much as a bow-string would be strung. To keep the warp strands spread apart the desired width, two pieces of thick, leathery birch-bark are perforated with a straight row of small holes corresponding in number with the number of strands to be used, and the distance between the perforations corresponding

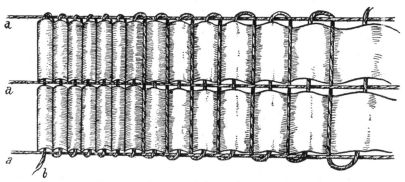

FIG. 35.—Woven technique, without sewing.

with the width of a flattened porcupine-quill. A piece of bark so prepared is placed at each extremity of the warp elements, with a strand running through each perforation. At this stage the loom is set ready for the weaving operation.

Several attempts have been made to secure a loom set up for this technique, but the best result obtainable in this direction is a piece of unfinished work with the birch-bark ends still in position, and a native description of the manner in which the warp strands were stretched on a bow, from which the illustration (fig. 36) was made. In figure 35 the warp strands are marked *a*; another strand, marked *b*, which may be included among the weft elements, is attached to the outside warp strand and then made to pass alter-

nately over and under the warp to the opposite side where it turns and crosses over again, passing under those strands which it crossed over during the previous movement. This operation is repeated to completion. Meanwhile, porcupine-quills have been woven in between the warp strands, over and under the crossing elements.

As the work proceeds the quills are crowded together, so much so that the crossing strands are hidden between the corrugations; in fact, the only strands showing in a finished piece of work are the two on the outer edges, and the loops of the crossing strands, which together form a selvage edge.

As the length of a quill becomes exhausted, the end is allowed to pro-trude at the back of the work; another quill is inserted with its end in the same position, then the crossing cord *b* is driven tight against the two ends, and the weaving is continued. The quills are used in a moistened, pliable condition; when they become dry, they are stiff and hard, and do not break away from such a fastening. After the work is finished the protruding ends are cut off close to the weave.

In the unfinished specimen of this work, the piece of bark at the lower end of the loom (fig. 36) slides freely up and down the warp strands, suggesting its use as a weave-sword to drive the quills up tight and insure a straight line across the weave. From the accuracy with which the quills are lined across the weave it is evident some implement must have been used to bring about the exquisite

FIG. 36.—Quill-work in process—the warp strands stretched on a bow used as a loom.

finish so noticeable in this work. From a mechanical point of view the piece of bark referred to is an ingenious adaptation if we assume that it was used both as a spreader for the warp strands and as a weave-sword.

This form of decoration has the appearance of being composed of fine, cylindrical beads. Specimens have been collected from the northern Athapascan tribes, the Indians of the Great Lakes, and the Iroquois. Owing to the technique, the designs are angular. However, some very striking patterns have been produced, especially worthy of notice being that illustrated in the frontispiece, in which the harmonious blending of colors is typical of porcupine-quill work generally.

The greater part of the detail of the art of porcupine-quill work thus far described is of such a nature that the designs are inclined to angular patterns, due no doubt to the methods employed and in some measure to the fact that many of the specimens examined were collected from Indians of the Plains, whose art seems to have been more or less influenced by their environment—with the ever-present cone-shaped tipi, perhaps the distant mountain peaks, the trails, and other objects suggesting straight lines, all of which were more or less conventionalized in their designs.

Geometrical designs, however, are not uncommon in the work of the Woodland Indians; but the art of these people to some extent indicates a tendency toward designs suggesting plant life, the absence of which is noticeable in the art of the Plains tribes. Thus may the question of environment be considered also in the art of the Woodland people.

Tendrils, stems, branches, leaves, and flowers are represented sometimes in realistic fashion. The graceful curves of nature are reproduced with remarkable skill in most exquisite line-work, involving many intricate foldings of the quills and seemingly impossible stitches, especially when we consider the fact that the most primitive tools were used—an awl, perhaps made of bone or simply a thorn, and for a needle the stiffened end of a sinew thread.

A number of methods of folding the quills have been employed by the Woodland Indians in representing plant life that were not

used by the people of the Plains, whose style of art consisted mainly of covering extensive surfaces, that is, patterns with a solid background of quills.

Plate xx illustrates an entirely different style. An exquisite floral design has been worked, leaving the leather to form a background. Conventionality has not been carried so far as to obscure

Fig. 37.—Use of two quills of contrasting colors on a lace of deerskin.

the artist's intention of faithfully representing leaves and flowers with their stems and gracefully curving tendrils. The specimen referred to is one of many collected years ago, but either the record of it has been lost or none was made, so that its origin is not certainly known; but after comparison with readily identifiable modern work, there is every reason to believe that this choice piece of porcupine-quill embroidery is of Iroquois origin. There are

Fig. 38.—Reverse of the edging shown in figure 37.

several techniques in this specimen which are not found in the work produced by the Indians of the Plains. The edges of the pouch and shoulder-straps (the straps are not shown in the illustration) are embellished with a very ornamental technique consisting of a series of quills wrapped over a filler and sewed to the edges. Figure 37 illustrates the use of two quills, one overlapping

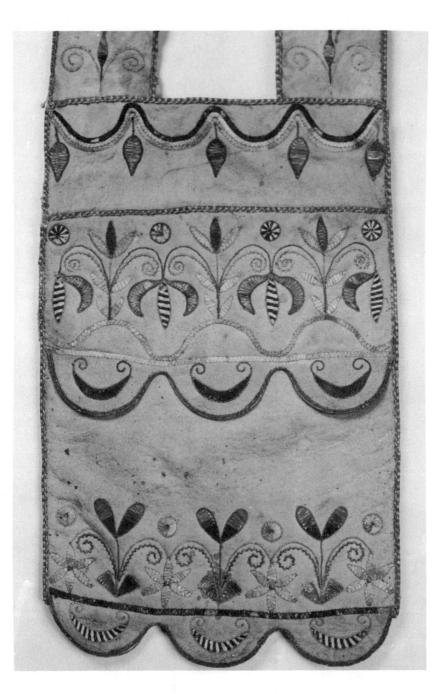

PLATE XX

QUILLED POUCH

1/1069 IROQUOIS W: 6½ IN

the other, of contrasting colors, which have been turned over a lace of soft deerskin forming a filler. Stitches have been made over each quill, as may be seen in the drawing. Figure 38 illustrates the reverse view of this edging, which at first glance has very much the appearance of beadwork along the edges of the object.

In figure 39, instead of two quills, one has been used. The drawing shows the method of folding and the direction of the stitches,

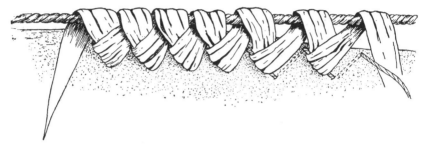

FIG. 39.—Method of folding a single quill on a cord of sinew or vegetal fiber.

also that a cord of sinew or perhaps of vegetal fiber has been used instead of a deerskin lace.

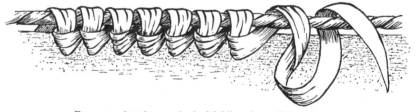

FIG. 40.—Another method of folding the quill for edging.

Figure 40 illustrates an entirely different fold of the quill, but the stitches are carried over the lower turns of the quills as shown in figure 39.

Figure 41 represents a single-quill edge with a fold similar to that shown in figure 37, but the treatment of the stitches is different, each stitch being made to cross the quill in two places instead of one, thus changing the appearance of the edging.

There is a possibility that the two methods last mentioned express the individuality of the makers, as they occur but once in

all the specimens examined. Unfortunately the provenience of the specimens is unknown, but the general character of the design suggests the art of eastern Indians, probably the Iroquois.

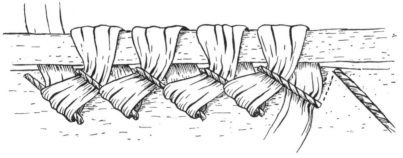

FIG. 41.—A single-quill edge with change in treatment of the stitching.

Another variation of a single-quill edging in conjunction with a cord filler is shown in figure 42. The simple foldings and stitches are clearly shown in the drawing, therefore further description is unnecessary. This edging appears on a specimen collected from the Iowa tribe. It is a very old piece, and as the edging is the only one showing this particular folding, the treatment may be placed in the individual class. This statement as to individuality must

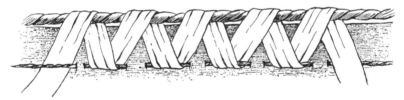

FIG. 42.—Variation in single-quill edging with a cord filler.

not be accepted as positive, as no doubt there are many specimens of quill-work that as yet are not accessible for examination.

An attractive edging is represented in figure 43. The quills have been folded in such manner as to form a sawtooth pattern, with the points of the teeth turned away from the edge. Stitches have been passed through the loops of the turnings, into the surface of the leather and out at the extreme edge. The edgings described are all made up of very fine quills and small stitches, and the work

is drawn so close together that the stitches are hidden, except in that edge shown in figure 41; but the sewing is so fine and tightly drawn in this case that it is barely visible. These fine edgings are not found on modern work, for although some attempts to approach it have been made, the results are coarse and ragged, and do not possess that fine finish so characteristic of the old work.

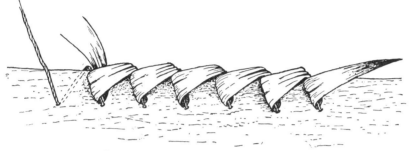

FIG. 43.—Quill edging of sawtooth pattern.

Another method of decorating an edge is shown in figure 44. Here the quills have been folded over the edge of the leather from front to back, both sides having the same appearance. Spot-stitches have been carried entirely through, catching first one side, then the other. This technique has not only been applied to deer-

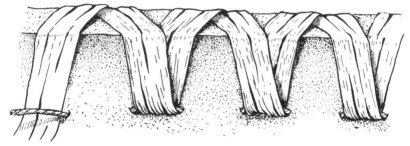

FIG. 44.—Edging produced by folding the quills from front to back.

skin, but frequently appears on intestine containers for quills, an illustration of which may be seen on plate II . This specimen has been decorated at both ends.

An examination of the detail of the work illustrated on plate XX will show that the leaves and flowers have been outlined with

a fine, hair-like line. Figure 45 depicts the method employed. The quill is flattened and twisted in such manner that a stitch is made between each turn of the quill; the thread is caught into the leather under the upper, and passes over the lower turn, entirely

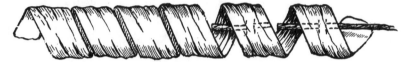

FIG. 45.—Detail of the method of outlining shown on Plate XVIII.

concealing the sewing. A line so made can either be turned in an unbroken curve or made straight to conform to the artist's desire. Such lines occur so small and fine that it is almost incredible they could have been made without the use of a fine needle and thread.

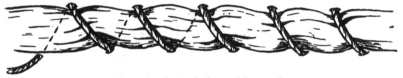

FIG. 46.—A simple form of line-work.

A simple but crude form of line-work is shown in figure 46. In this case the quill has been simply laid on the article to be decorated and sewed over and over.

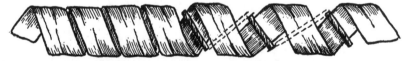

FIG. 47.—A form of folding with diagonal stitching.

Figure 47 represents the same folding as is seen in figure 45, but with diagonal stitching instead of a series of stitches made in the same direction as the line.

Figure 48 illustrates a method of making a raised line. The quills have been wrapped around a sinew cord, or perhaps a split bird-quill, and sewed to the decoration by passing the stitches through the loops formed by the quills as they were wrapped around

the filler. A variation of this is shown in figure 49. in which, in addition to the bird-quill filler, a string or small cord is included

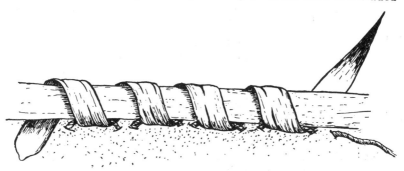

FIG. 48.—Method of making a raised line by wrapping around a core of sinew or of split bird-quill.

and the stitches are made over that, instead of through the loops of the quills.

These raised lines are rather striking in effect and are found frequently around the outer edge of a panel of some floral design, but not as a fine line around the edges of leaves, etc. Because these lines have a filler, it must not be thought that they are at all

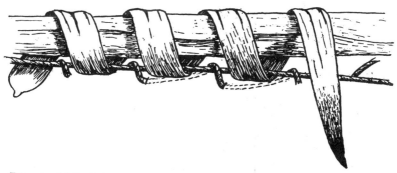

FIG. 49.—Method of making a raised line with a string in addition to the usual filler.

coarse, as some have been measured that are only a sixteenth of an inch in diameter.

Another raised-line effect appears on a game-bag decorated by the Loucheux. The folding of the quills is similar to that shown in

figure 21 and also like the pipe-stem braid in figure 32. In the Loucheux work a cord has been laid under the quills between the stitches (fig. 50), producing a very neat, rounded appearance to the line. This specimen of line-work is one-eighth of an inch wide.

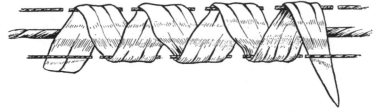

FIG. 50.—Raised-line work, a cord being laid under the quills.

The beautifully curved tendrils illustrated on plate XX are made with a complex folding of the quills, producing what may be called a double serrate line. Figure 51 illustrates the direction of the folds of the quills, and also the position of the stitches. The

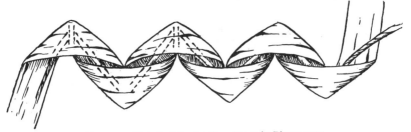

FIG. 51.—Detail of the folding shown in Plate XVIII.

dotted lines indicate the stitches following the shape of the teeth and the points at which they enter the leather under the apex of each turn.

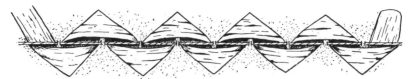

FIG. 52.—A variation of the folding shown in Figure 51.

A variation is shown in figure 52, in which case the sewing is carried straight along the line, although the folding is the same as

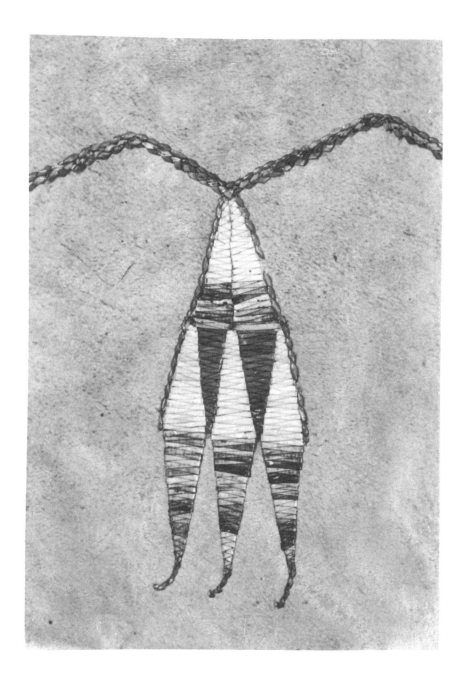

PLATE XXI
QUILL DECORATED PIPE BAG; DETAIL
4/2437 *GROS VENTRES. MONTANA* 4½ x 5½ IN.

in the last example. It will be observed that the thread is caught into the leather between the points. In both instances, however, the work is done so neatly and is drawn so tightly that the sewing is entirely concealed. This technique has been observed in many specimens of the older work. Several pieces of modern work presenting the same technique have come to notice, but the fine finish of the early artists is lacking.

An interesting bit of line-work was found on a pipe-bag collected from the Cheyenne; it has the appearance of a very fine, single-link chain, and is made of quills with points and ends cut off and laid in loops crossing at regular intervals, and stitched over the crossings (fig. 53). Little or no attempt has been made to conceal the cut ends of the quills; nevertheless the work is so fine that this defect is hardly noticeable. The sewing is not hidden, but its exposure rather adds to the decorative effect than otherwise. The links are about one-eighth of an inch wide. This is the only piece of this technique that has come to notice, and it may be another expression of individuality.

A very neat line has been embroidered on several specimens in the Catlin collection, of unknown tribal origin, and reappears on a modern piece of work by the Gros Ventres (pl. XXI). The line crossing the upper end of the plate is the one referred to. The

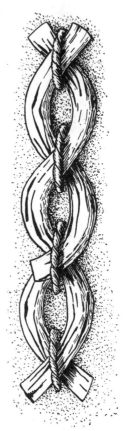

Fig. 53.—Line-work on a Cheyenne pipe-bag.

illustration shows three rows of quills. The technique of the top row has been described, and is illustrated in figure 45. The two lower rows are of an entirely different technique. In making this line two quills of contrasting colors have been used, and so folded as to form a pattern consisting of a series of interlocking diamonds (fig. 54). The dotted lines in the drawing indicate the method of

folding and the overlapping of the quills one over the other. A spot-stitch has been used, crossing the underlying folds, and the stitches are all concealed.

The specimen of Gros Ventre work shown in the plate does not present the fine, careful finish so apparent in the Catlin specimens.

FIG. 54.—Method of folding two quills of contrasting colors to produce series of interlocking diamonds. (See pl. XXI.)

Unfortunately the latter are in such a poor state of preservation that they are not suitable for illustration.

The regularity of the drawing in figure 54 is no exaggeration of the fine work produced by the earlier artists. Where so many methods have been employed for fastening porcupine-quills to materials receiving decoration, sporadic technique might reasonably be looked for, but, strange as it may appear, few cases have come to light. A good example is shown on pl. XXII , in which we have a unique condition in that the quills themselves have been made to take the place of a thread, that is, they have been stitched through the surface of the deerskin in the form of what is commonly known as a herring-bone stitch.

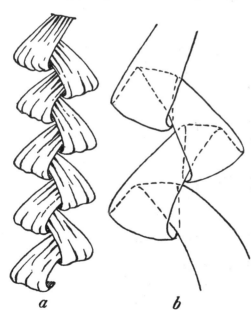

a *b*

FIG. 55.—Detail of method of threading the quills through skin. (See pl. XXII.)

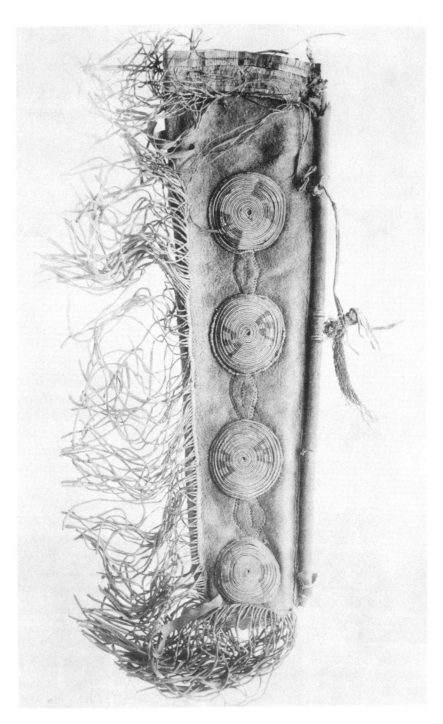

PLATE XXII
QUIVER OF NORTHERN PLAINS ORIGIN
UNITED STATES NATIONAL MUSEUM

The drawing (fig. 55) presents the method of threading the quills through the skin. Nothing like this has been found in the many specimens examined. In the first place, no thread has been used to fasten the quills, and the herring-bone pattern has not been used on any other specimen, so far as known. The piece of work referred to may be seen on the plate in the form of three diamond-shaped figures between the discs.

The fact that examples of individuality are so few (the workers being apparently satisfied with the methods commonly in vogue), and the wide distribution of many techniques, would suggest that the art of porcupine-quill work was practised many years before the arrival of Europeans on the American continent. A great length of time would be necessary for knowledge of the various methods to become so widespread.

Figure 56 is an enlarged drawing of a very delicate rosette

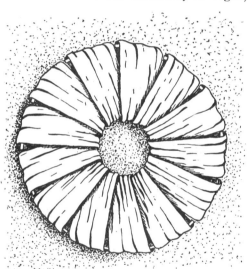

FIG. 56.—Rosette in quill-work.

which occurs on several unidentified specimens. In plate XX examples of this embroidery are shown with a fine, hair-like line worked around the edge of the rosette, the technique of which is shown in figure 45. Considering the size of the rosette in question, a trifle more than a quarter of an inch in diameter, this is a remarkable piece of work. The method of folding the quills to produce the circle is shown in the drawing (fig. 56); the outer edge is secured by the simple spot-stitch between each fold, while the center is held by a draw-string running through the loops of the quills and fastened into the leather with one stitch. Some of these rosettes show the use of two or more colors.

Fringe forms a common feature of the decorative scheme of the North American Indians, and is made usually of strips of deerskin ranging from an inch or two to eighteen or twenty inches long and from an eighth to a quarter of an inch wide, and is applied to clothing in various ways, as well as to other articles for which such decoration is suit-able. In many cases ornamentation has been applied to the strands of the fringe, such as wrapping them with porcupine-quills. Sewing has not been resorted to as a means of holding the quills in position where soft-tanned deerskin has been used for the fringe strands, but where raw-hide or other stiff leather has been employed, a thread has sometimes been used, under which the ends of the quills have been tucked,

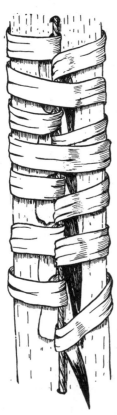

FIG. 57.—Method of ornamenting fringe with quill-work.

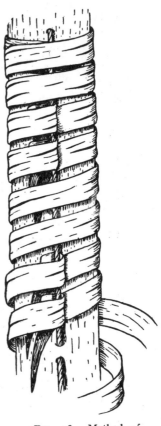

FIG. 58.—Method of ornamenting fringe with quill-work.

but not in the sense of sewing as applied to other techniques.

Figure 6 illustrates the method of fastening quills to a fringe of soft-tanned leather. The wrappings are laid over the ends, and where additional quills have been applied or spliced on, the two

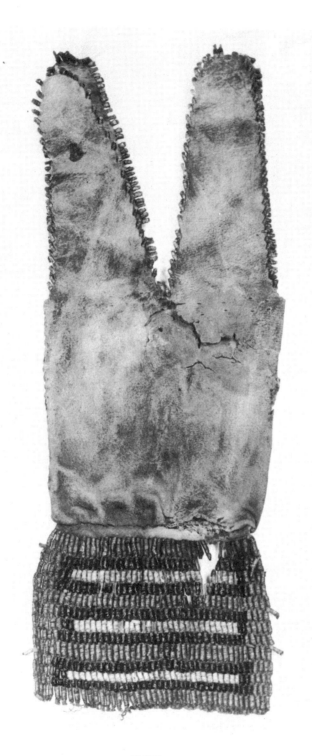

PLATE XXIII

QUILL DECORATED POUCH FROM A MEDICINE BUNDLE

2/8452 SAUK. IOWA 3x8½ IN.

ends are held together with a half-turn or twist and the wrappings carried over these twisted ends. This makes a continuous and secure binding that does not readily become displaced. The turns of the quills around the fringe strands are made close together, so that the splicing and the ends are concealed. Long strings for pendent objects and tie-strings for moccasins have been decorated in this fashion.

This method has been used to some extent where the fringe strips have been made from rawhide, such as is frequently found on pipe-bags. There seems, however, to have been a preference for the use of a fine cord fastened at each end of the fringe strip when made of rawhide. The ends of the quills were given a half-turn around the thread, and the wrappings passed over the ends as shown in figure 57. In this case the quills were wrapped so closely that the ends and the cord were concealed. A similar wrapping is shown in

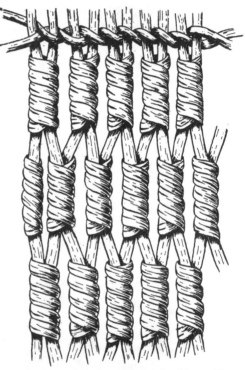

FIG. 59.—Method of ornamenting fringe with quill-work.

figure 58, with a variation, two quills being worked along together instead of a single quill.

Wrapped fringes were apparently very popular among the quill-workers of the past, and the liking for that form of decoration prevails among modern workers, although the work is not so care-

fully done. Judging by the specimens collected from the Plains tribes, they evidently had a preference for rawhide strips for fringes, except on clothing. Moccasins, however, are occasionally found with such fringe.

In many cases where stiff leather has been used for fringe, the strips have been fastened in such manner that they could not spread apart, and by the introduction of quills of various colors in measured spaces, some elaborate patterns have been worked out.

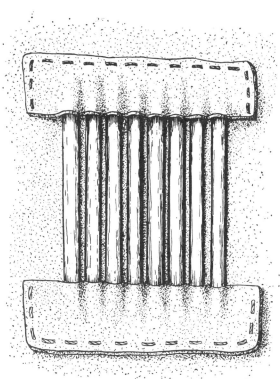

Pl. XXIII illustrates an interesting form of netted fringe made of a series of strands bound together in pairs. In figure 59 it will be seen that the first row of wrappings has taken the first and second strands, then the third and fourth, and so on across the width of the fringe. On the second row, the first strand alone has been wrapped, then the second and third, thus alternating the pairs with the row above, producing the net-like arrangement of the strands, with the quill-wrappings taking the place of knots of an ordinary net.

Fig. 60.—Example of crude quill-work by Thompson River Indians.

The drawing exaggerates the spread of the quills somewhat;

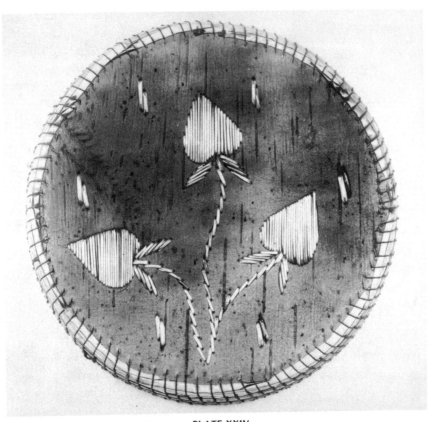

PLATE XXIV
MODERN COMMERCIAL BIRCHBARK BOX WITH QUILL DECORATION
CHIPPEWA. WISCONSIN

the example illustrated has the strands almost concealed, although another object collected from the same source had the strands only partly covered. The specimens referred to were parts of the contents of two very old medicine-bundles collected from the Sauk and Foxes. Some attempt to introduce design was made by a change of colored quills producing straight lines across the fringe, which show indistinctly in the illustration. To secure the wrappings, the ends of the quills were tucked under the first and last turns, as is clearly shown in the drawing.

A rather crude piece of quill decoration emanated from the Thompson River Indians of British Columbia. The decorated objects consist of some horse trappings. The porcupine-quills have been cut into short lengths and are held in position by pieces of deerskin sewed over both ends of the quills which are laid side by side as shown in figure 60. This example is recent work and is said to be a survival of an old form of decoration.

A young Paiute man, a student at the Carlisle School, was questioned as to his knowledge of porcupine-quill work among his people. His request for materials being complied with, he fashioned an ornament as illustrated in figure 61. This is made of sections of quills cut in equal lengths and threaded as one would string beads, with a piece of leather between the sections of quills. According to his statement, it is an old form of decoration among his people, was sometimes made several feet in length, and was used as part of a woman's headdress.

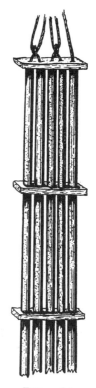

FIG. 61.— Threaded quill-work made by a young Paiute.

DECORATION OF BIRCH-BARK

The process of fastening porcupine-quills to birch-bark for decorative purposes is found to be very simple when compared with similar work on leather. Sewing is entirely dispensed with.

Perforations are made in the bark with an awl somewhat smaller in diameter than the quills, following a design which has been drawn with a blunt-pointed implement usually made of bone or antler. A lead pencil is frequently used for tracing designs on modern commercial articles. The perforation is made immediately before the end of the quill is inserted, when the bark contracts to some extent and holds the quill tight. Unflattened quills are invariably used in this form of decoration.

Plate XXIV illustrates the cover of a birch-bark box, such as is frequently found for sale at summer resorts and in curiosity shops. The design is simple, and easily and quickly applied—an important feature duly considered by the Indians when an article is made for sale. The edge has been trimmed with sweet-grass sewed with commercial thread. However, the specimen well serves the purpose of illustrating quill-decoration on birch-bark in its simplest form. The design has been worked out very tastefully, and there is a certain charm in its simplicity.

The methods employed in this case are the same as have been used on all quilled birch-bark. The design is outlined with a blunt-pointed instrument. Sometimes a stencil or cut pattern is used to guide the marker: this fact speaks for itself in the illustration, which shows three leaves to be of exactly the same shape and size. Light pressure with the bone marker produces a well-defined line on the bark which is not easily obliterated. Some specimens have been examined which show that the design had evidently been drawn without the aid of a pattern. In these instances, however, duplication of design does not occur to any extent. When the drawing is completed, the artist proceeds to fit the quills to the pattern.

The treatment of the stems of the leaves in our illustration resembles what is known as the "outline stitch" in modern embroidery, but with the difference that the quills do not form a continuous thread as in the case of an embroidery stitch, but are cut off close to the bark on the under side; that is to say, each stitch is simply a short piece of quill with its ends turned down into the bark. This is effected by passing the quill point first through a

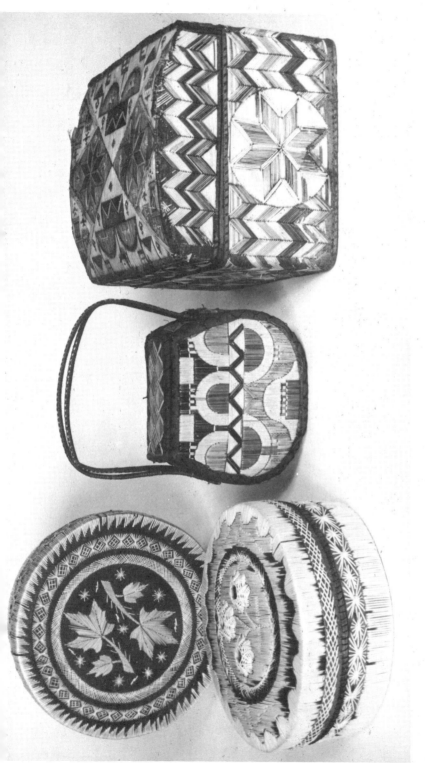

PLATE XXV

QUILL DECORATED BARK CONTAINERS

CIRCULAR BOX WITH SWEETGRASS
CIRCULAR BOX AND COVER
BIRCHBARK BASKET BAG
RECTANGULAR BOX AND COVER

CHIPPEWA. ONTARIO
CHIPPEWA. ONTARIO
MICMAC. NOVA SCOTIA
MICMAC. MAINE

13/7212
21/124
1/98
10/96

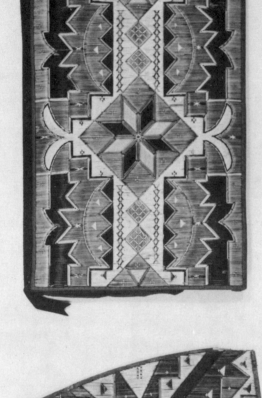

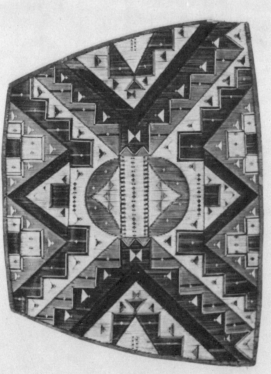

PLATE XXVI

BARK PANELS WITH QUILLWORK DECORATION

2/8471

CHAIR SEAT
MICMAC. NOVA SCOTIA

12/6115

PORTFOLIO COVER
MICMAC. MAINE

10½ x14 IN.

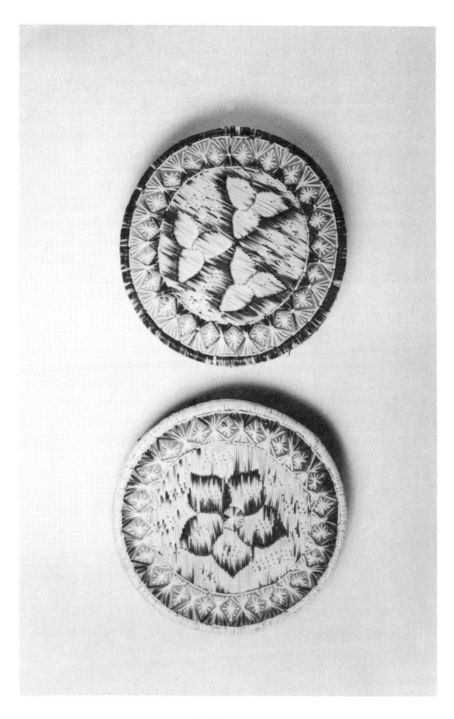

PLATE XXVII
QUILL DECORATED BIRCHBARK BOX AND COVER
OJIBWA
CONTEMPORARY

perforation, from the under side, then from the upper side to the back, and cut off. Sometimes a quill is long enough to make several such stitches.

The leaves are given similar treatment: perforations are made along the outline, quills are inserted across the leaf, and cut off in the same manner as for the stems. This bears a resemblance to the "satin stitch" in our embroidery. Many specimens showing realism in design have been collected from the Indians inhabiting the Great Lakes region, while those to the eastward have produced more designs of a geometric nature. New Brunswick and Nova Scotia seem to lead in the latter form of decoration. Plates XXV-XXVII present some elaborate geometric designs. An artistic selection of colors has added greatly to the exquisite workmanship of the quill-work on the specimens illustrated.

The rectangular box represented in pl. XXVII shows a variation in decoration around the sides of the cover. Excepting a small square shown in the center of the picture, the sides have been wrapped with split spruce-root and decorated with interwoven quills in rhomboids and squares. This form of ornamentation occurs frequently and is often found to cover the sides of the boxes as well as the sides of the covers, but no box has been found with the top so decorated.

In nearly every case in which a birch-bark box is decorated with porcupine-quills, a thin piece of bark has been secured to the reverse side of the decoration, possibly as a protection for the cut ends of the quills, and in any event adding a very neat finish to the inside of the box.

PLATE XXVIII

QUILL DECORATED DEERSKIN MOCCASINS

19/6359; 19/6361; 19/6362 DELAWARE. PENNSYLVANIA?

PLATE XXIX

QUILL DECORATED KNIFE SHEATHS

19/6355
DELAWARE

3/2873
DELAWARE

19/6340
CHIPEWYAN

19/4548
CHIPEWYAN

19/6534
DELAWARE